J.W.

Dog Days

by Jamie Wyeth

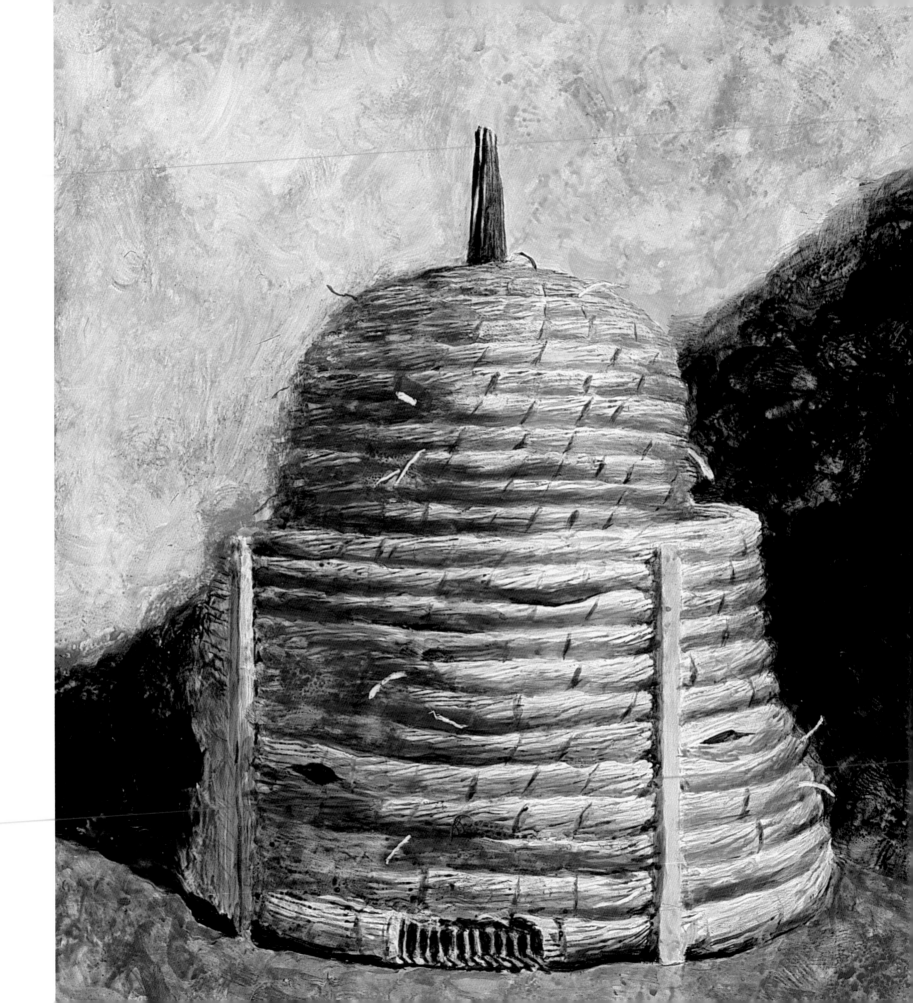

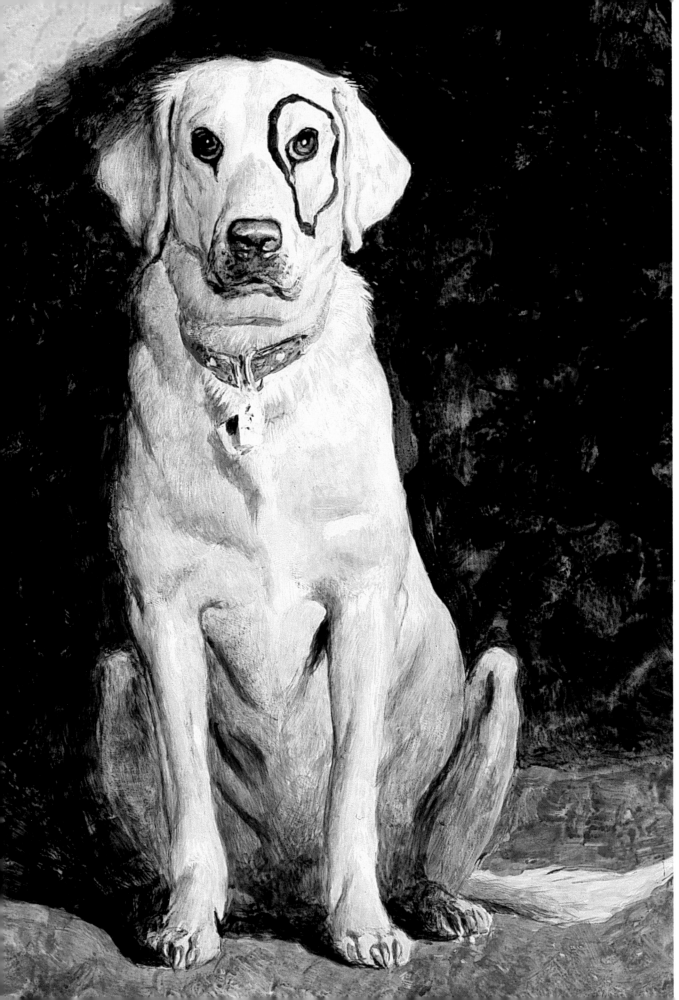

Kleberg and the Hive, 1985

Combined mediums on paper,
14 1/2 x 22 1/2 inches
Private Collection
(Not included in the exhibition)

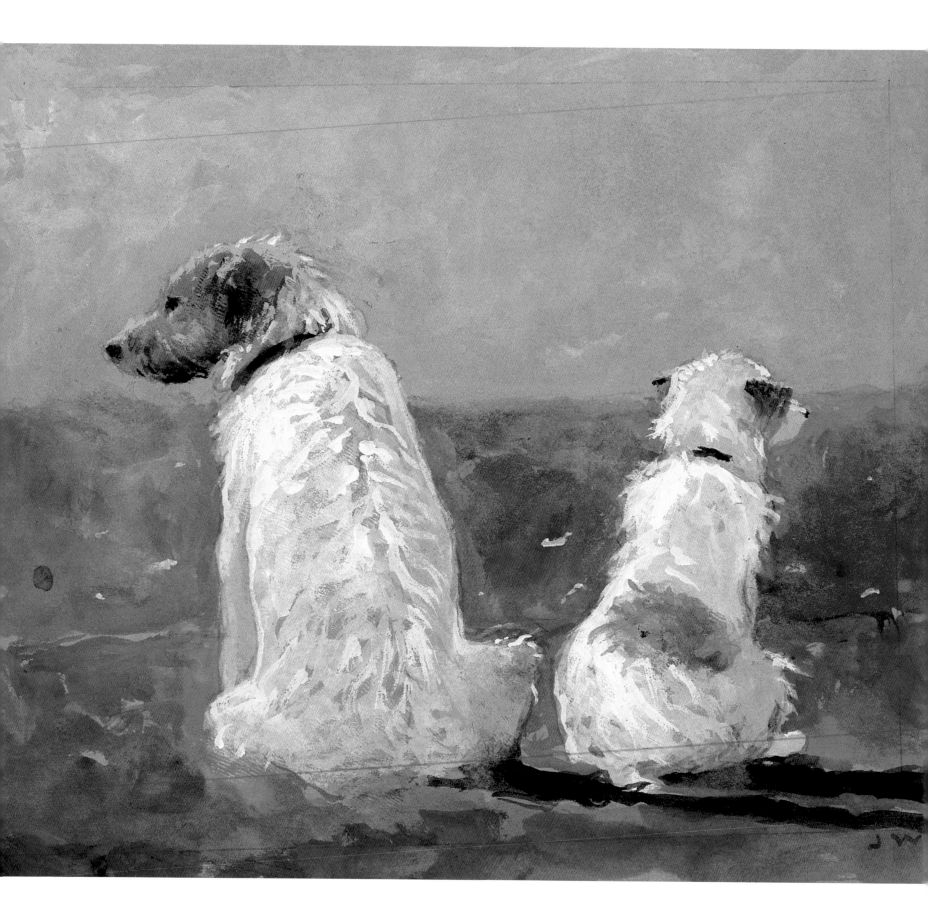

Dog Days

by JAMIE WYETH

Commentary by the Artist

BRANDYWINE RIVER MUSEUM

CHADDS FORD, PENNSYLVANIA

COVER:

DETAIL: **Ziggy Daydreaming,** 2001

Combined mediums on toned board,
18 x 24 inches
Collection of the artist

PARCHMENT FLYLEAF:

DETAIL: **Miss Beazley and Barney
Conferring, India Taking Notes
(Study #3),** 2005

Pencil and ink on paper,
7 3/4 x 5 3/4 inches
Collection of the artist

FRONTISPIECE:

**Theo and Wiley Taking in the
Sea Air,** 2005

Combined mediums on toned board,
5 x 6 inches
Collection of Mary Beth Dolan

This publication was made possible by a generous grant from the Davenport
Family Foundation. The exhibition, *Dog Days of Summer: Works by Jamie Wyeth*, was
supported by The Davenport Family Foundation Fund for Exhibitions.

The Exhibition: June 9 through September 3, 2007

A Brandywine River Museum Publication
© 2007 Brandywine Conservancy, Inc.
Library of Congress Catalogue Number: 2007927408
ISBN: 978-0-9795872-0-7
All rights reserved.
3rd Printing, February 2013

Designed by Libby Woolever
Printed by Pemcor, Inc., Lancaster, Pennsylvania

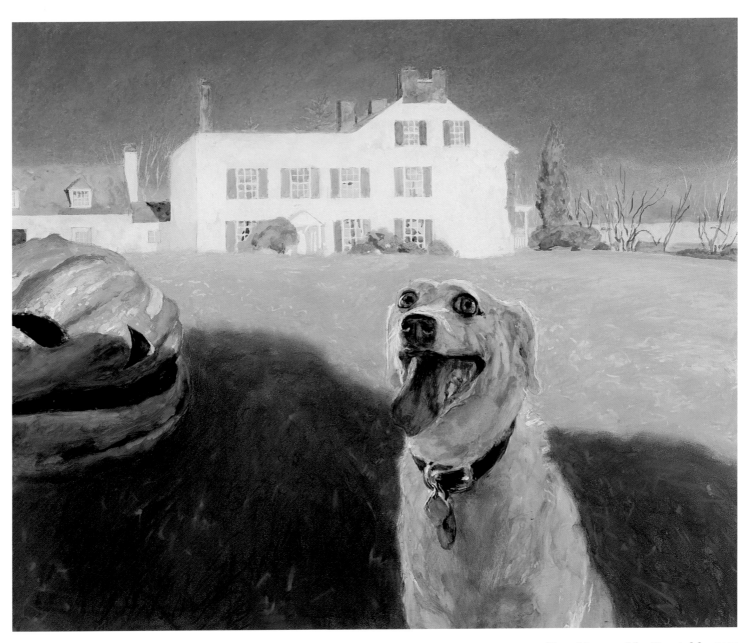

Dog Menaced by Vegetable, 2001

Pastel, watercolor, gouache, and varnish on toned board, 24 x 30 inches
Private Collection

Preface

It seems appropriate that Jamie Wyeth surrounds us with dogs; he often seems surrounded by them himself. Even when he is not drawing or painting them, dogs are by his side. They seem domestic manifestations of his intense fascination with animals of almost any kind. Pigs, chickens, cattle, horses, sheep, goats, gulls, geese, turtles, and even sharks and vultures have been his subjects. He paints them all with respect and devotion, recognizing defining characteristics and conveying distinctions with great understanding and technical skill. These are individual animal's portraits, even when the critters perform only supporting roles in works of broader or multiple meanings.

The sheer amount of Jamie Wyeth's art depicting dogs gave impetus to this publication and the exhibition it represents. With so many diverse canine images confronting curators, it seemed natural to suggest a close look at this always compelling subject. The exhibition was held at the Brandywine River Museum during the summer of 2007, and thus was titled "Dog Days of Summer: Works by Jamie Wyeth."

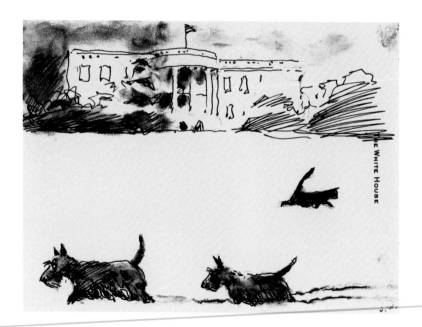

The artist supported this undertaking from the moment it was suggested. We are grateful for the time and many kinds of support he gave, and especially for his extensive and entertaining comments about his life with art and dogs and much more. Jamie Wyeth, always a raconteur, can best document the works reproduced in this book.

India, Barney, and Miss Beazley on the Southwest White House Lawn (Study #10), 2005

Pencil and ink on paper, 5 5/8 x 7 3/4 inches
Collection of Mr. and Mrs. Frank E. Fowler
(Not included in the exhibition)

Lee Wierenga, Assistant Curator, eagerly assembled the exhibition, borrowing from many collections and developing a comprehensive look at the present subject. She also oversaw the development of this catalogue which, notably, reproduces more of the artist's canine personalities than were seen in the exhibition. Moreover, she was key to the interview with the artist that produced fascinating results.

Financial support for the exhibition came from an endowment at the museum and the Davenport Family Foundation Fund for Exhibitions. Beyond the gallery installation, this publication was generously supported by an additional and much appreciated grant from the Davenport Family Foundation. We are also in debt to the many lenders to the exhibition and those who provided photography to make possible the reproductions seen here.

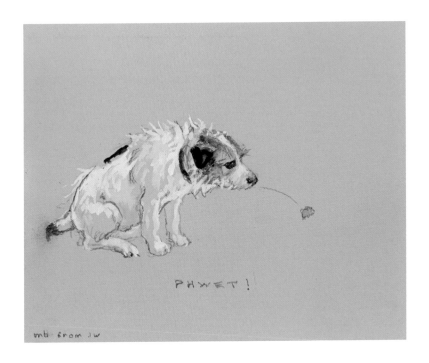

Jamie Wyeth has drawn and painted dogs throughout his career, so that we find them rendered in all of the complex media and techniques he has used during more than four decades. His craftsmanship is extraordinary. His depictions of dogs are sometimes illustrations, often thought-provoking, often humorous. They are always sympathetic, full of character and beautiful. We delight in them and take pride in this presentation.

James H. Duff
Director

Homer – Phwet!, 2004

Combined mediums on toned board,
4 x 5 inches
Collection of Mary Beth Dolan

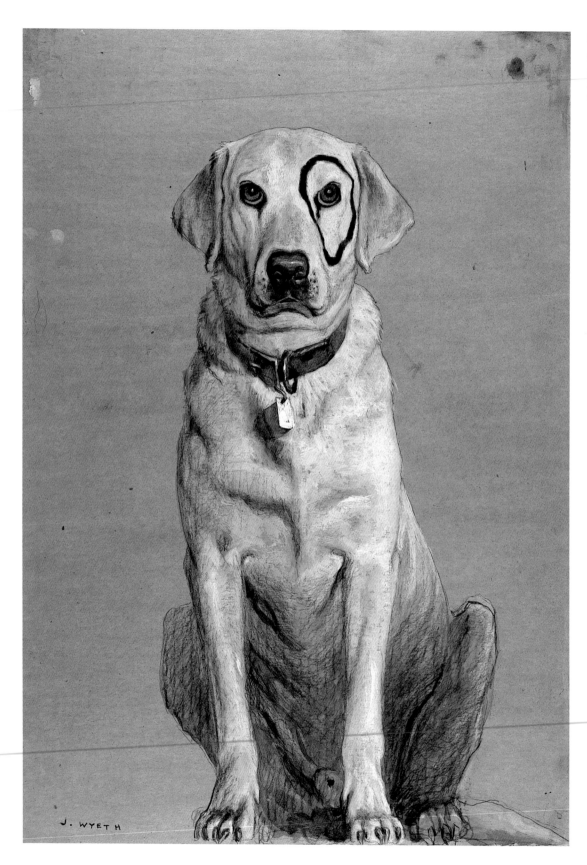

Study for Kleberg, 1984
Combined mediums
on cardboard,
29 x 20 1/2 inches
Private Collection

Acknowledgments

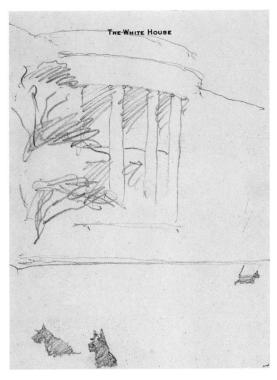

**Miss Beazley and Barney Sitting,
India Leaving (Study #6),** 2005

Pencil and ink on paper, 7 3/4 x 5 3/4 inches
Collection of the artist

Development of the exhibition, *Dog Days of Summer: Works by Jamie Wyeth*, and this publication required the assistance and support of many people. Mary Beth Dolan and Helene Sutton were relied on for their knowledge of provenance. They patiently endured seemingly endless questions as well as numerous requests for photography. Thanks are also extended to those who helped locate paintings in private collections: Frank E. Fowler and his assistant Jeanne Janney, Victoria Manning of Somerville Manning Gallery, Lauren Bergen of Sotheby's, Priscilla Vail Caldwell of James Graham & Sons, Inc., and Rebecca Szantyr of Thomas Colville Fine Art. They were invaluable in the development of this project.

The following individuals are thanked for graciously lending paintings and drawings from their collections: Mr. and Mrs. Douglas Adkins, the Cawley family, Dr. and Mrs. Donald Counts, Mary Beth Dolan, Mr. and Mrs. Frank E. Fowler, Sherry Kerstetter, Jamie Michaelis, the Rosenblum family, Mr. and Mrs. Richard Sanford, Daniel K. Thorne, Mr. and Mrs. Brock Vinton, Phyllis Wyeth (the artist's wife), and seven individuals who wish to be anonymous. The Terra Foundation for American Art and Thomas Colville Fine Art, LLC also lent important works to the exhibition.

It was a pleasure working with Libby Woolever whose fine design is evident throughout this publication. Instrumental in the development of the exhibition were Jean A. Gilmore, Registrar; Bethany Engel, Assistant Registrar; and Drew Bjorke, Preparator. The photograph of Jamie Wyeth surrounded by his dogs was taken and provided by Michel Arnaud.

A huge debt of gratitude is owed Jamie Wyeth, who enthusiastically participated in many phases of this project. In addition to lending works to the exhibition, he spoke at length about dogs and his art. His words form the basis of the text to follow and his images…well, they sit up and speak for themselves.

Lee Wierenga
Assistant Curator

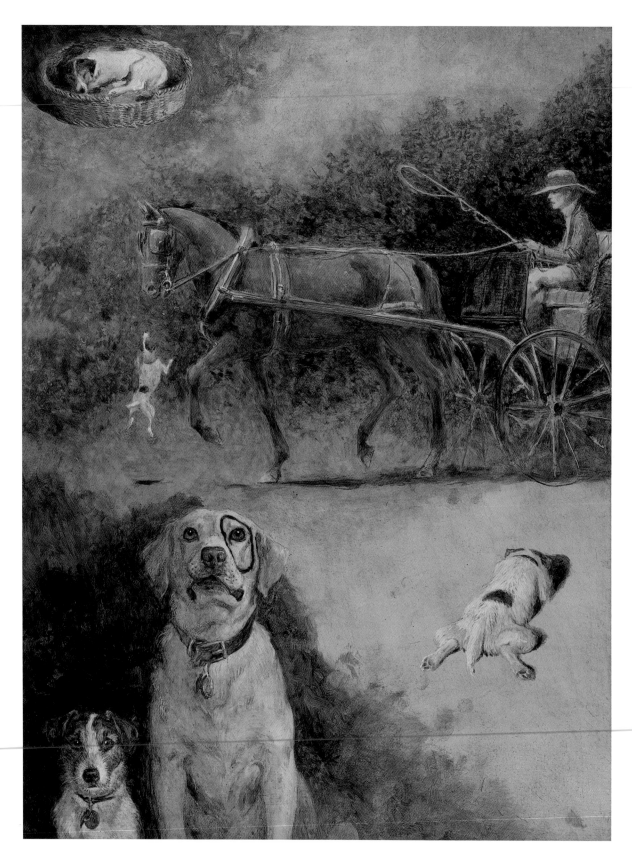

A Day in the Life of Dozer Wyeth, 1983

Oil on toned board,
12 x 16 inches
Collection of Phyllis and
Jamie Wyeth

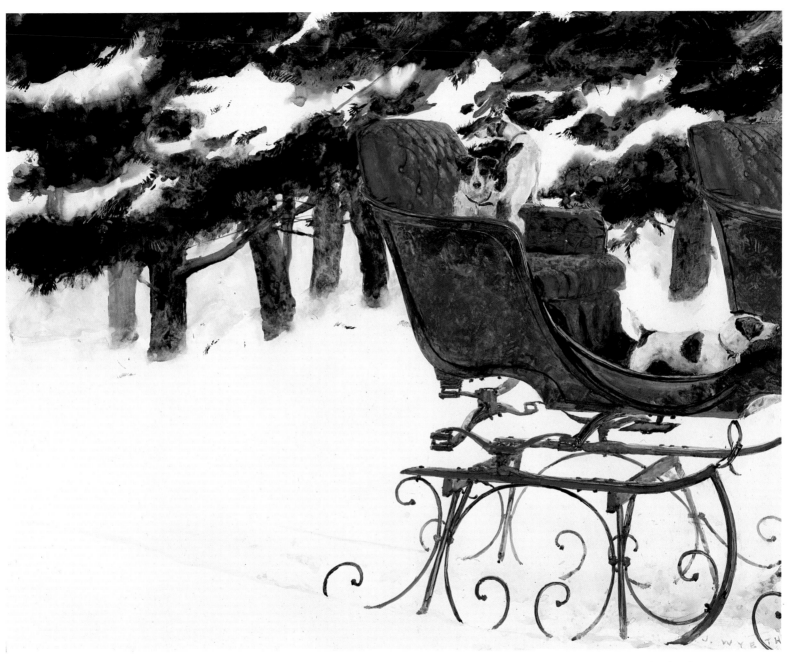

Jack Russell Sleigh, 1987

Combined mediums on paper, 23 x 29 inches
Collection of Mr. and Mrs. Frank E. Fowler

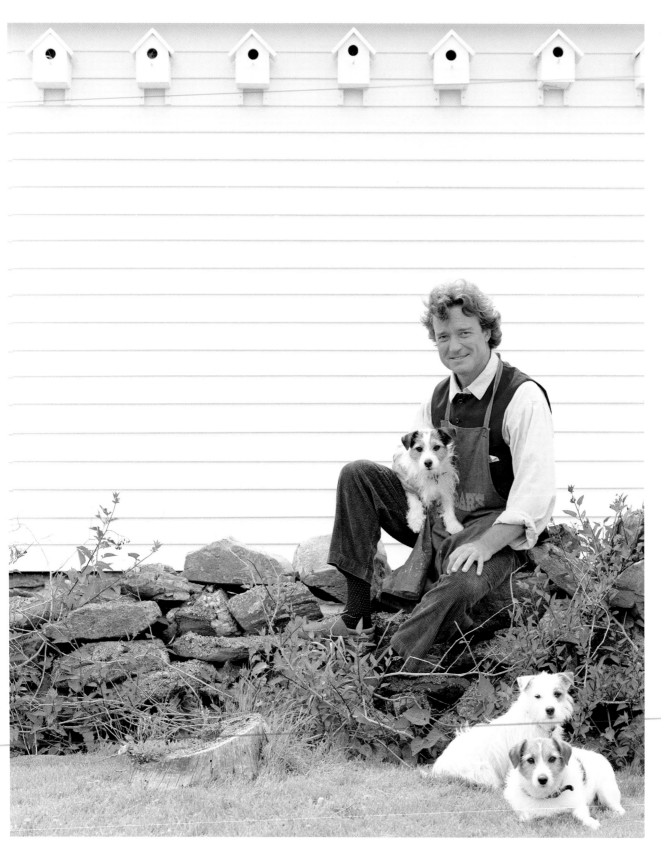

14

Dog Days by Jamie Wyeth

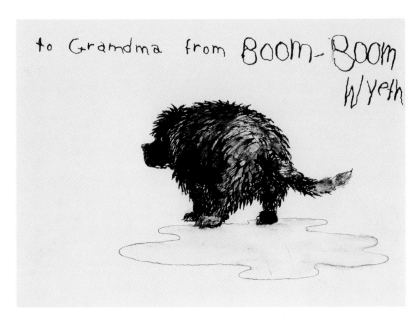

To Grandma from Boom Boom Wyeth, circa 1970

Ink on paper, 4 7/8 x 5 1/4 inches
Collection of the artist

The words to follow are the artist's. Jamie Wyeth was interviewed a few months before the exhibition opened. He spoke about dogs and many other aspects of his art and career. The questions from the interview have been deleted and his words assembled into a continuous commentary. The conversational tone of his remarks remains.

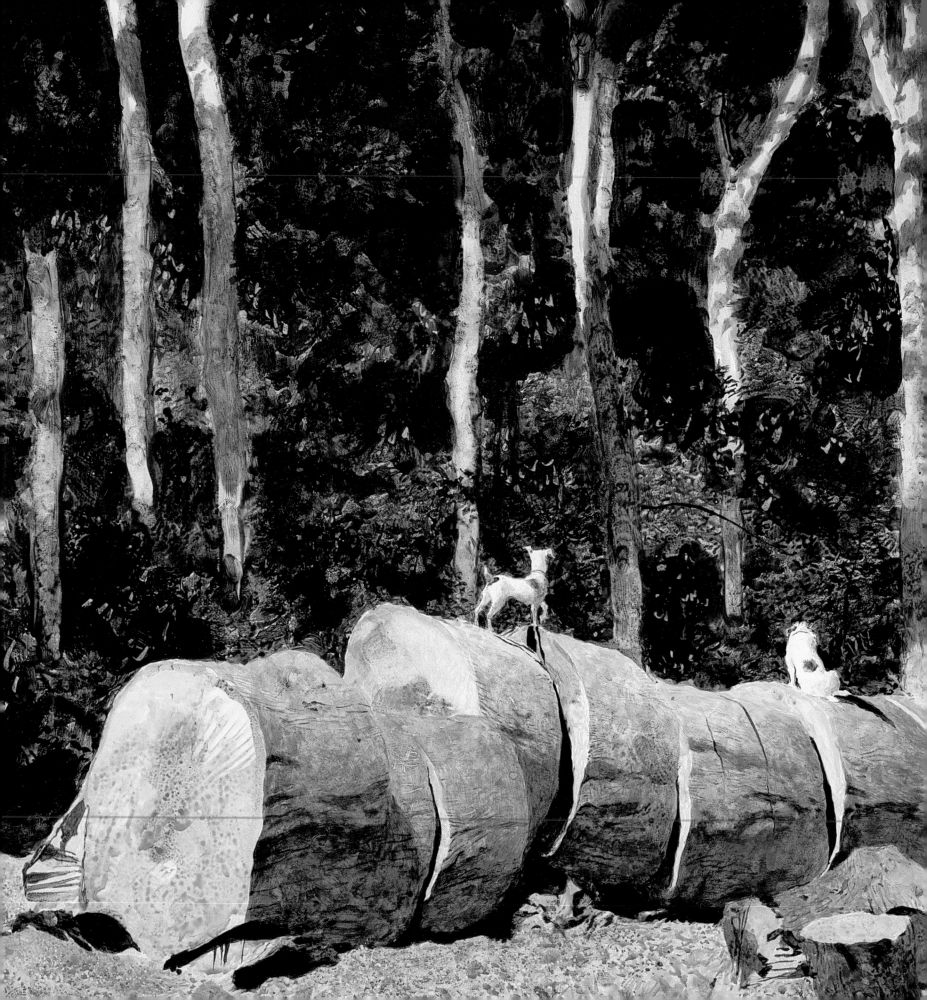

*I have no memory of my
first drawings of dogs.*

Dozer and Egg, 1985

Combined mediums on paper, 19 x 24 inches
The Gerard L. Cafesjian Collection
(Not included in the exhibition)

I may not have done many when I was very young. I think the first would have been of our family pets. "Eloise" was a poodle given to us by friends when I was eight or nine. I did endless drawings of her, lots of them, from puppy on up. I remember that was my first real involvement with a dog. But I don't know what was my first major work with a dog. Would *Newfoundland* have been the first really big dog work? I guess everybody thinks of that painting, *Newfoundland*, a painting of my dog "Boom Boom." But there had to have been other dog paintings before that. My interest in using dogs in painting is just that they are easy models. They're around me, so I grab them and tie them down. It's really more about availability of models than it is about the dogs. I've turned to this subject so often because they're around me. You know that's when pigs, dogs and things like that are done. They're around me, so I use them as my models.

The Summer in Maine, 1983
Combined mediums on paper,
22 3/4 x 28 3/4 inches
Private Collection
(Not included in the exhibition)

I don't have a favorite model.
Each one is its own little world.
Each is a favorite.

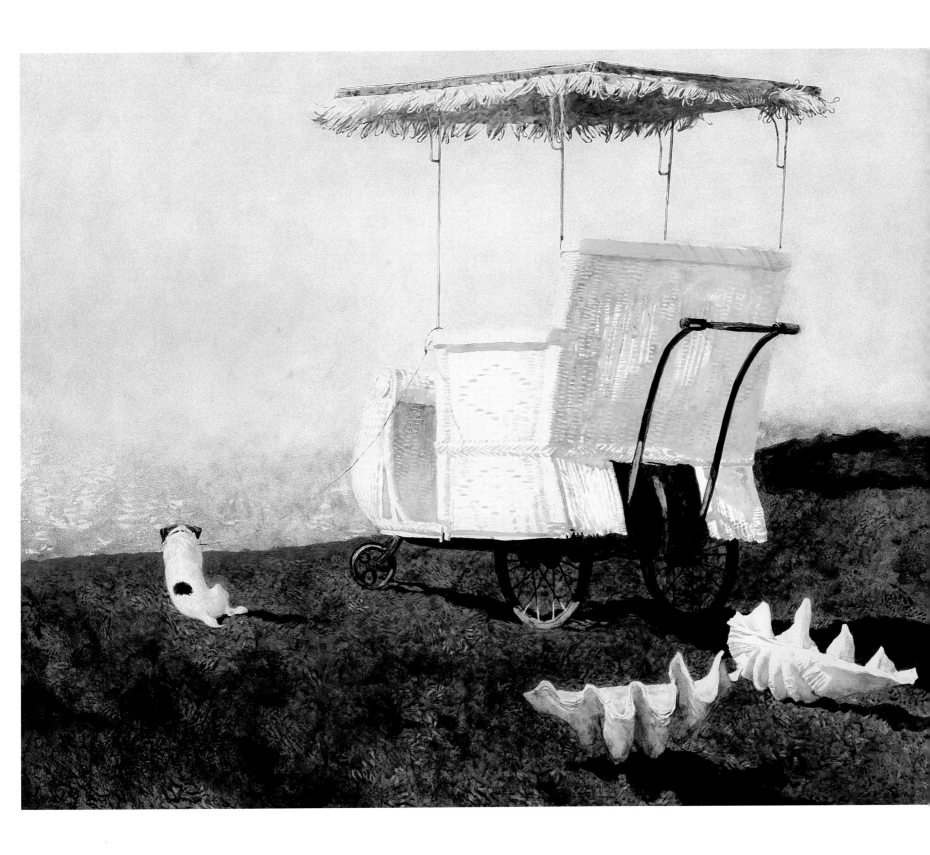

Kleberg, Partly Cloudy, 1997

Combined mediums on toned board,
16 x 20 inches
Collection of Douglas and Susan Adkins

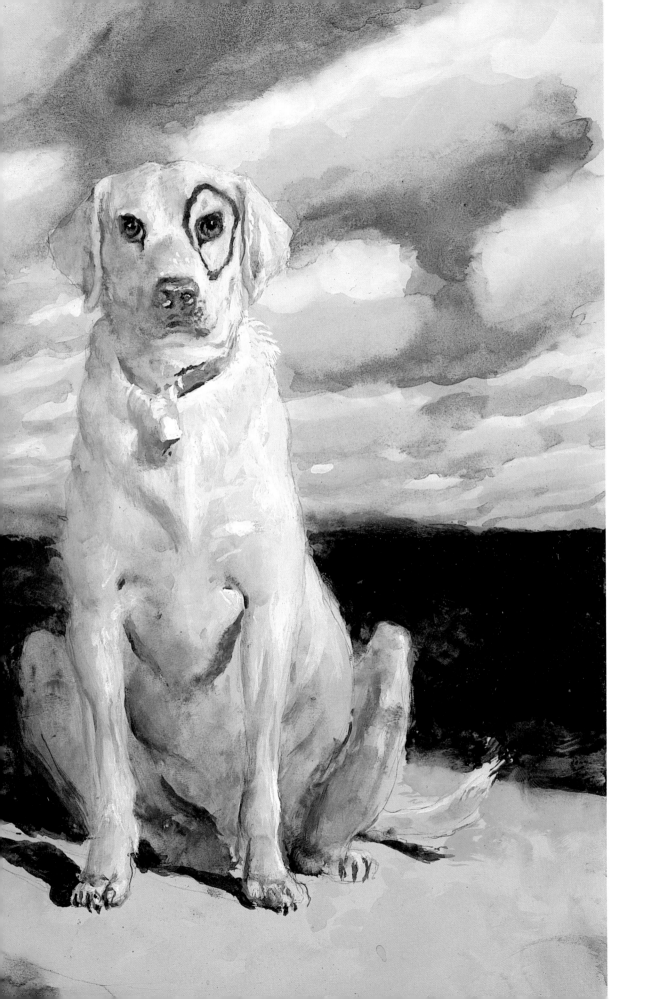

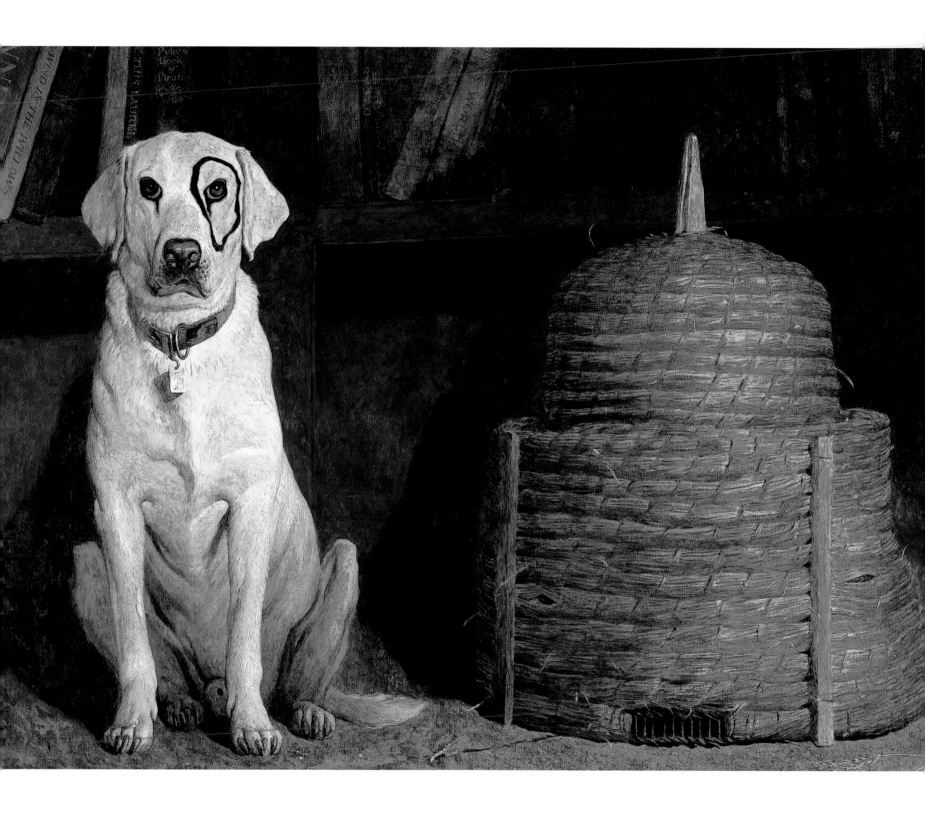

I don't need the subject during the entire time I am working.

When people pose for me, it's not that they sit frozen in a chair. I spend a lot of time with them, being with them and doing drawings. It's kind of a process of osmosis rather than working with a frozen sitter. And, of course, dogs won't be still unless they are asleep. You know, most of them are used to me and they hang around my studio. Kleberg was given to me. He'd been my wife's brother's dog, a hunting dog. He became very shy of gun shots, and so I ended up with him. He would sit in my studio next to the easel as I was working.

Kleberg, 1984

Oil on canvas, 30 1/2 x 42 1/2 inches
Terra Foundation for American Art,
Daniel J. Terra Collection, 1992.164

**Study of Kleberg (For Jamie –
his First Christmas)**, 1984

Combined mediums on cardboard,
Unknown dimensions
Private Collection
(Not included in the exhibition)

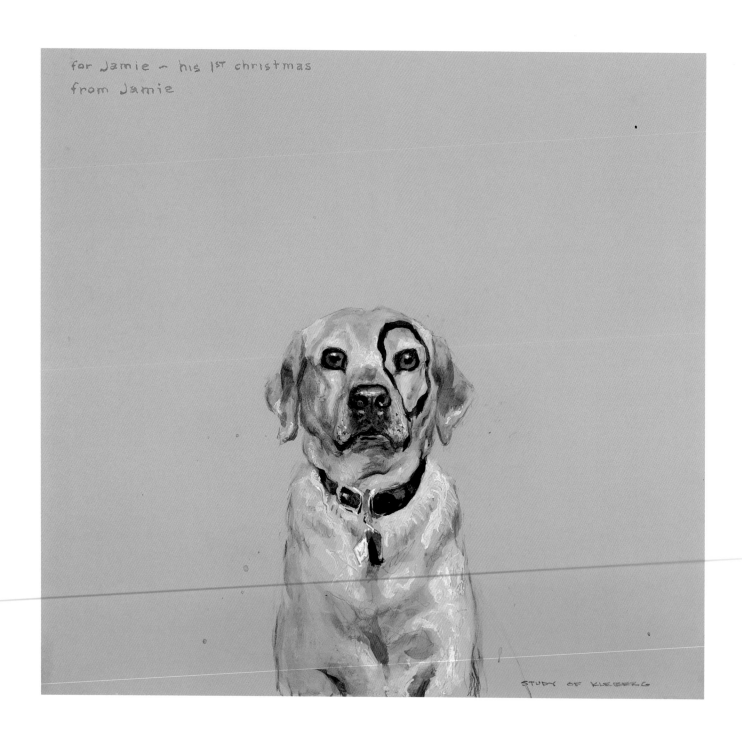

Kleberg, Awake and Asleep, 1984

Combined mediums on toned board,
dimensions unknown
Private Collection
(Not included in the exhibition)

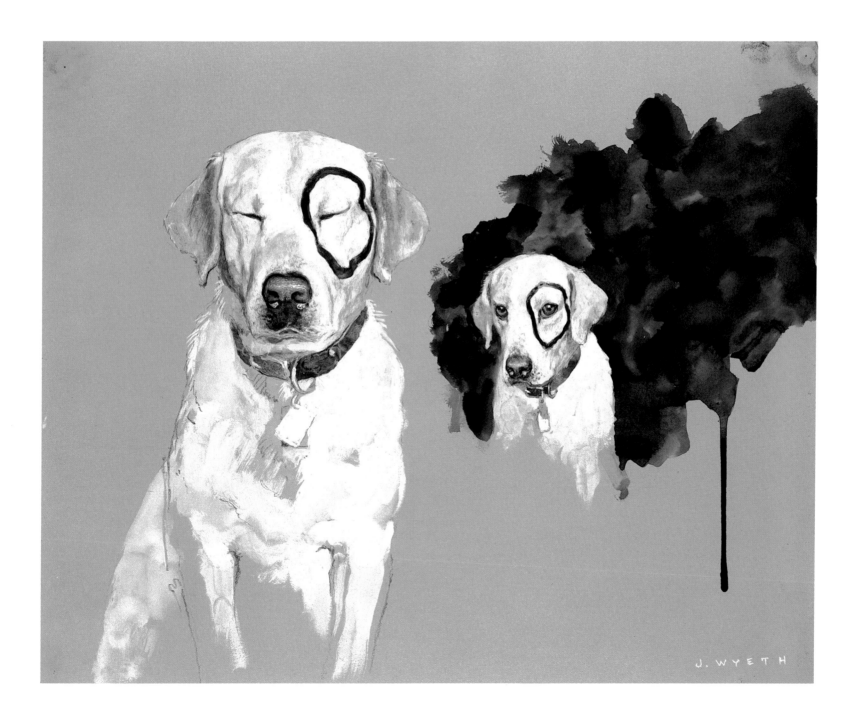

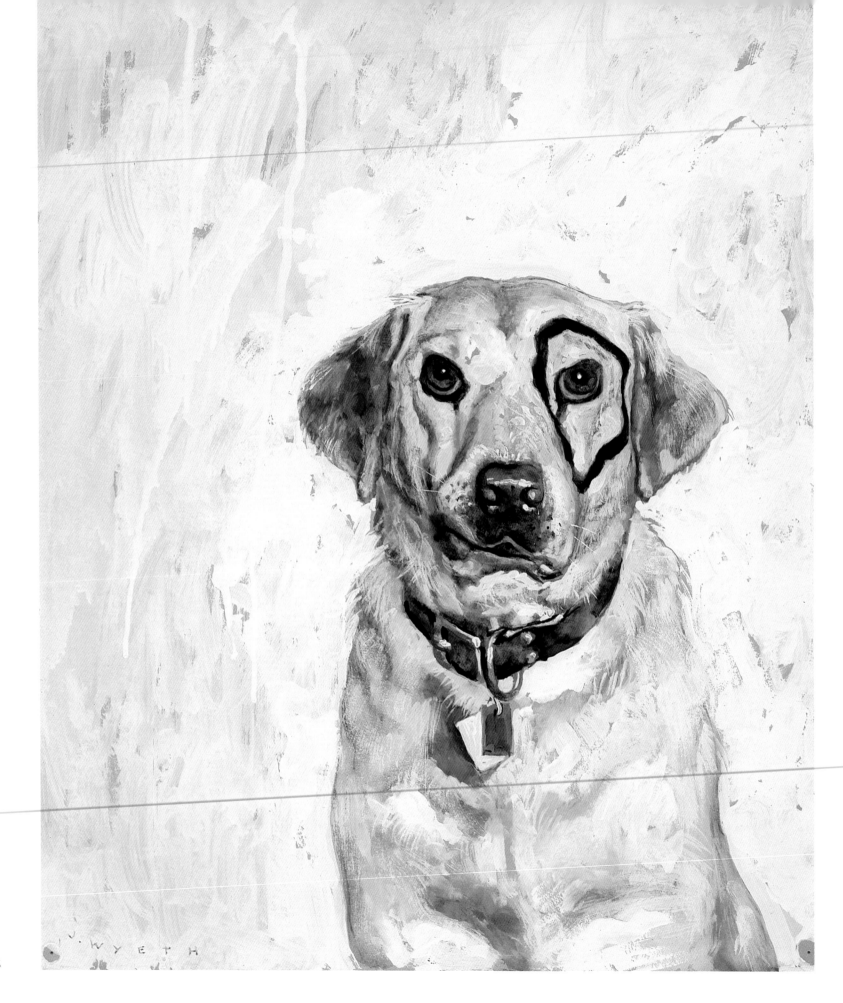

One day I put some black on my brush and put a circle around his eye.

He loved it, and I loved it. Later I realized that there was more to it because I always loved Petey of the *Our Gang* comedies. I recently saw Petey again, and he not only has a circle but he has an eyebrow too which I totally missed. It is really quite funny. It's a circle with a little dash. Painting the circle continued for a long time with Kleberg — until the day he died. Of course people would marvel at the amazing marking on that dog. I freshened the circle often. Finally we worked it out with some moustache dye, and that really worked well. I painted it on about once every month and a half or so. He sat there — he let me do it. Of course, only his hairdresser should know this.

Kleberg Study — White Wash, 1984

Combined mediums on toned board,
22 1/2 x 18 1/2 inches
Collection of Phyllis and Jamie Wyeth

I have done so many dogs.
It's hard to say if there are dogs I haven't liked.

When I illustrated *The Stray*, I turned the stray into a dog. Several of the other characters in the book were dogs. But the Lynch character was definitely a dog, and dogs have followed me through my life and my career.

Vice President's House, 1996

Oil on canvas, 24 x 36 inches
Private Collection
(Not included in the exhibition)

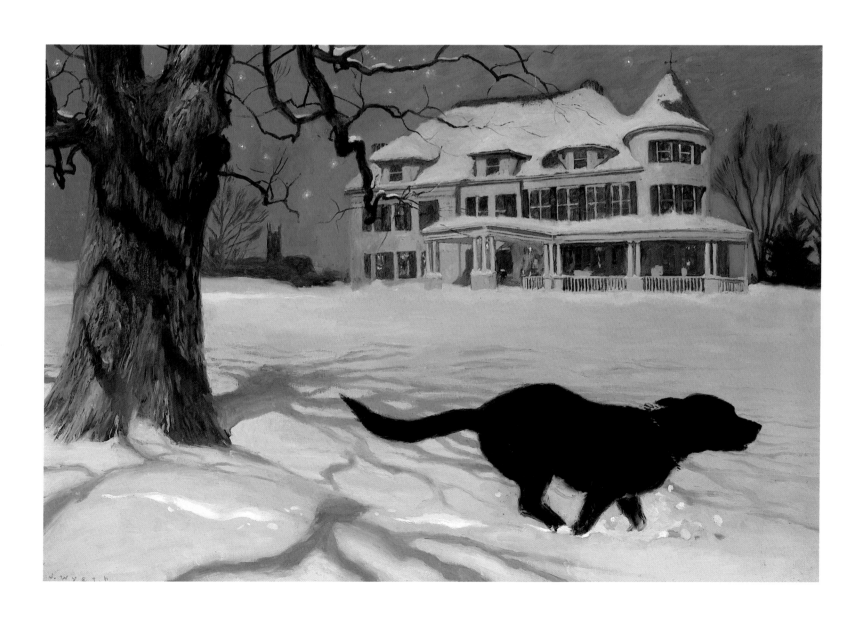

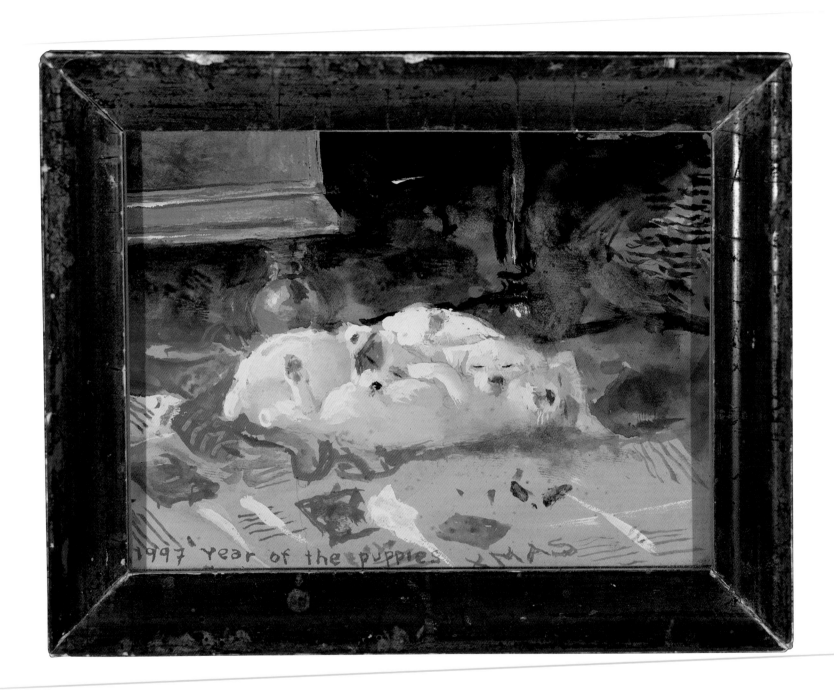

It is hard for me to make distinctions among the dogs.

Year of the Puppies, 1997

Combined mediums on toned board,
5 1/2 x 7 inches
Collection of Phyllis and Jamie Wyeth

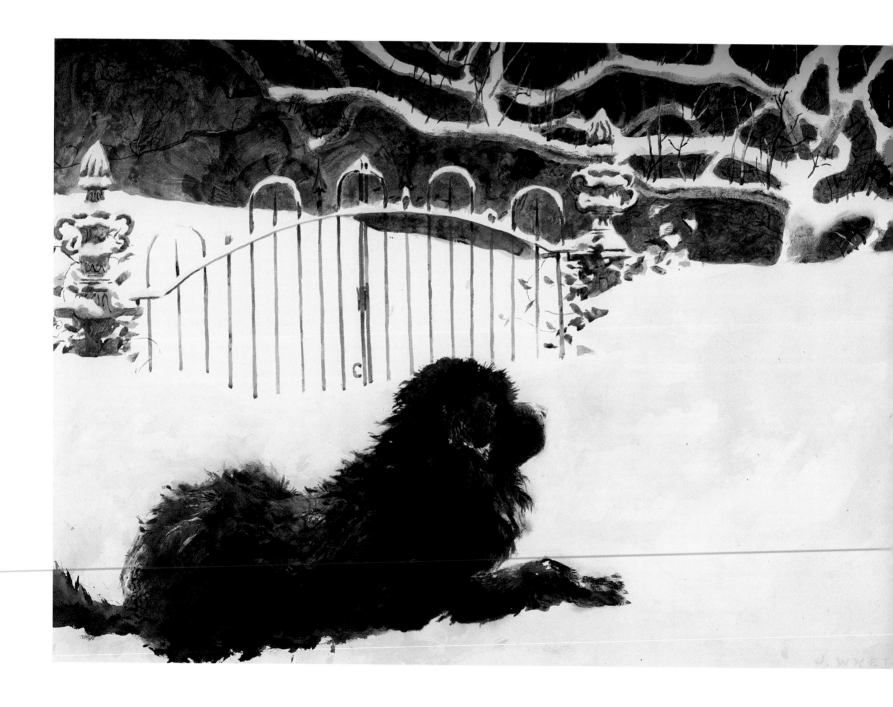

Boom Boom was wonderful in his total inconvenience. I kind of liked that inconvenience. Boom Boom would swipe tables with his tail and he was sort of a drool factory. He would shake his head and the saliva would end up on the ceiling and he had a sort of majesty about him.

The tragedy of big dogs is they die so young. That is what I hate — and the death of a dog wrecks me infinitely more than the death of a person.

So after Boom Boom, I said no more big dogs. He was stolen one time. He disappeared from the farm and I was frantically looking for him. A reporter came to me, and apparently newspapers love nothing more than dog stories. The reporter was extensively interviewing me about an exhibition, and I happened to mention that my dog had been stolen. He said, "WHAT, your dog has been stolen?" Then he said, "You wouldn't happen to have been painting him would you?" "Of course," I said. "Yes, I was." Of course, I wasn't. It went on the wire services, and it was picked up by nearly every paper in the country. The story was called "Boom Boom Gone Gone." He was found almost instantly outside of Philadelphia. Whoever had him either couldn't afford to feed him, or they realized it was hard to hide a Newfoundland, a big black Newfoundland. The New York Times sent a pool photographer to photograph Boom Boom returned. People go crazy for dog stories. Boom Boom was a total celebrity.

Boom Boom in Winter, 1980

Watercolor on paper, 25 1/2 x 36 inches
Collection of Jane Wyeth
(Not included in the exhibition)

Newfoundland, 1971

Oil on canvas,
30 x 58 1/2 inches
Private Collection

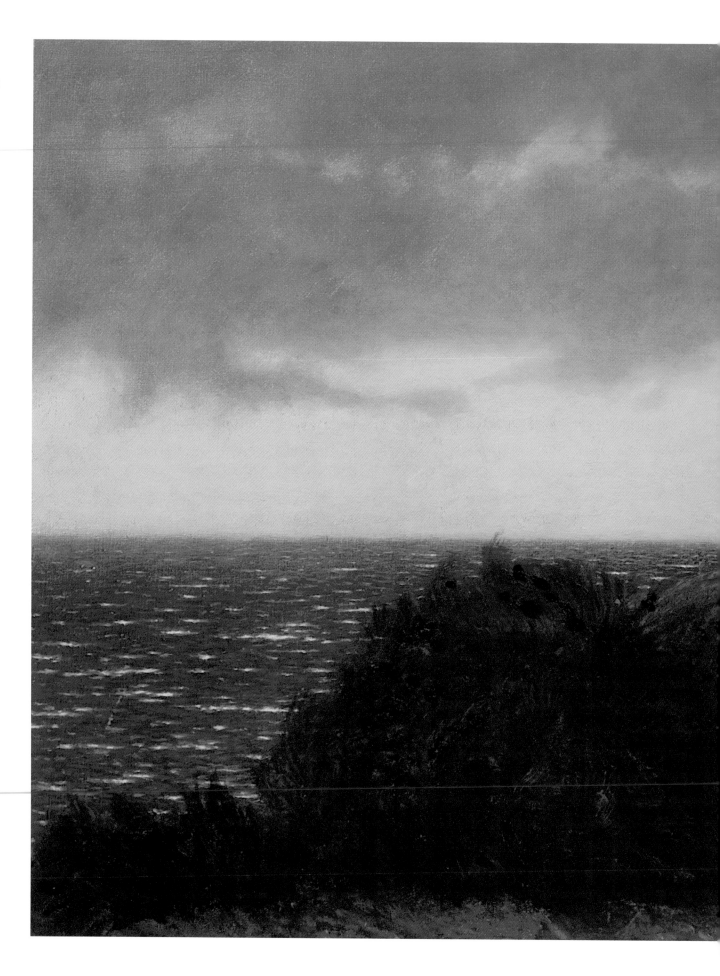

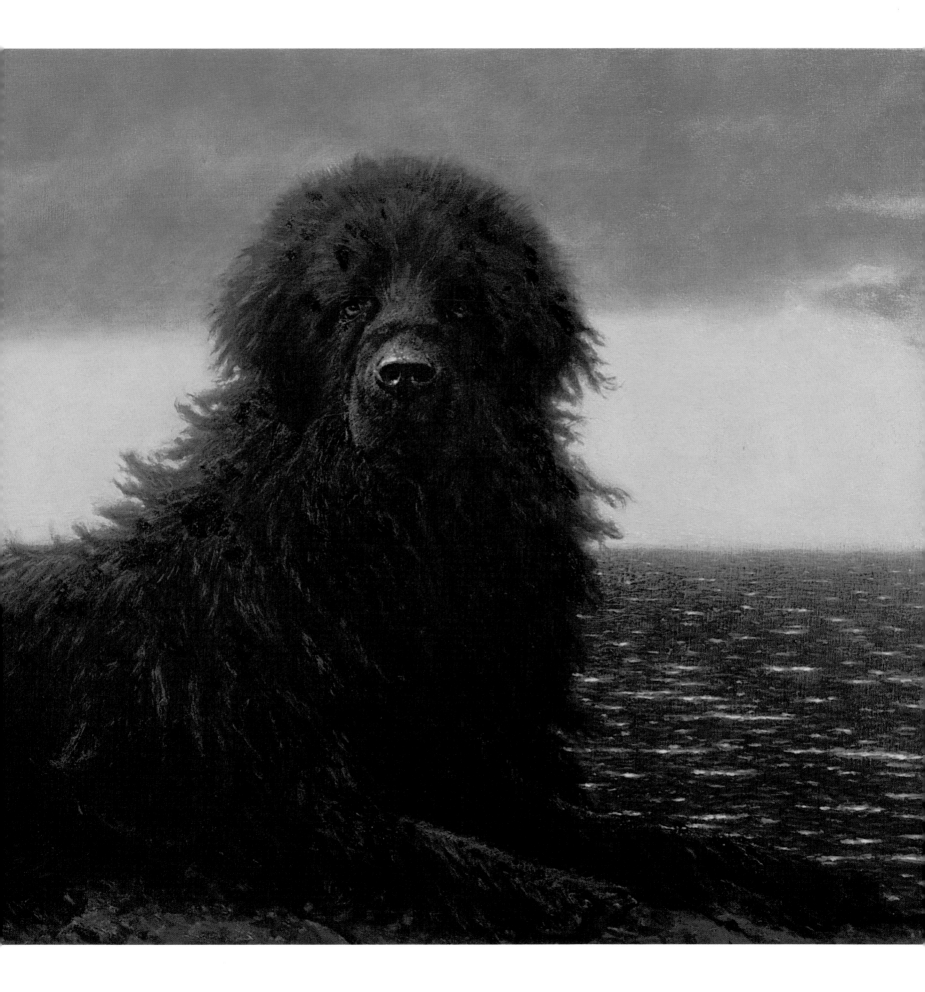

You know *Newfoundland* has a rather sad story. The painting was owned first by Gregory Peck. Then I started to get letters from their son essentially saying that "dog" is "God" spelled backwards and asking if I was aware of that and of the power of this painting. He went on and on about the painting. Sadly, he committed suicide. The next time I saw the Pecks, we were in New York and they announced that they couldn't keep this painting because it was so aligned with this boy, and they said that the hour he died the painting fell off the wall. It was just bizarre.

When Bobby Kennedy was the attorney general he would take his Newfoundland, Brumus, in the back of his convertible.

And take him everywhere because he was this incredible dog. When Bobby died, Brumus sensed it and became incredibly protective of the family. When a Newfoundland gets protective, it's very scary. Finally they had to put him down. It was so sad because he was part of the family.

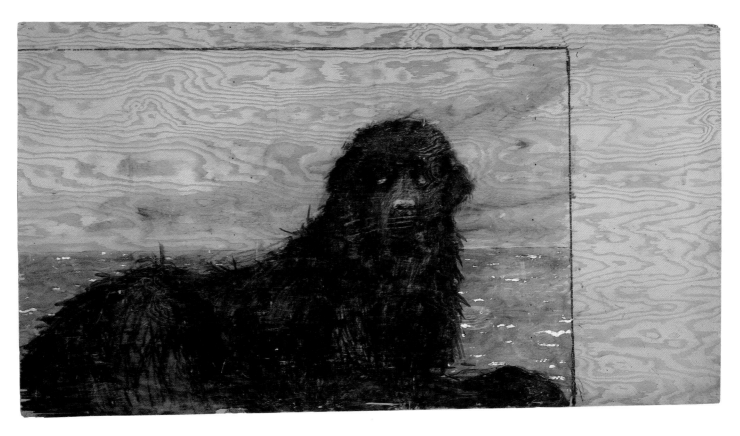

Newfoundland Study, 1971

Oil on plywood, 32 x 59 3/4 inches
Collection of the artist

One picture that seems like an anomaly is Wolf Dog.
It is genuinely different in its feeling.

It was painted on Monhegan Island. I had been to Alaska and met these mushers, who drive dogs. They have the oddest combination of breeds pulling the sleds including boxers and retrievers. It's just bizarre. This guy offered to send me a lead dog — a musher dog. I said o.k. The dog was shipped to the island, and it was 3/4 wolf and 1/4 Malamute. They use this kind for the lead dogs. They are the ones that sense the whole thing when they are going along, whether the ice is going to break, for example. That was an incredible process because he sent instructions: do not take him into your house, do not treat him as a pet, leave him outside.

Wolf Dog, 1976

Oil on canvas, 30 x 40 inches
Collection of Donald and Kathryn Counts

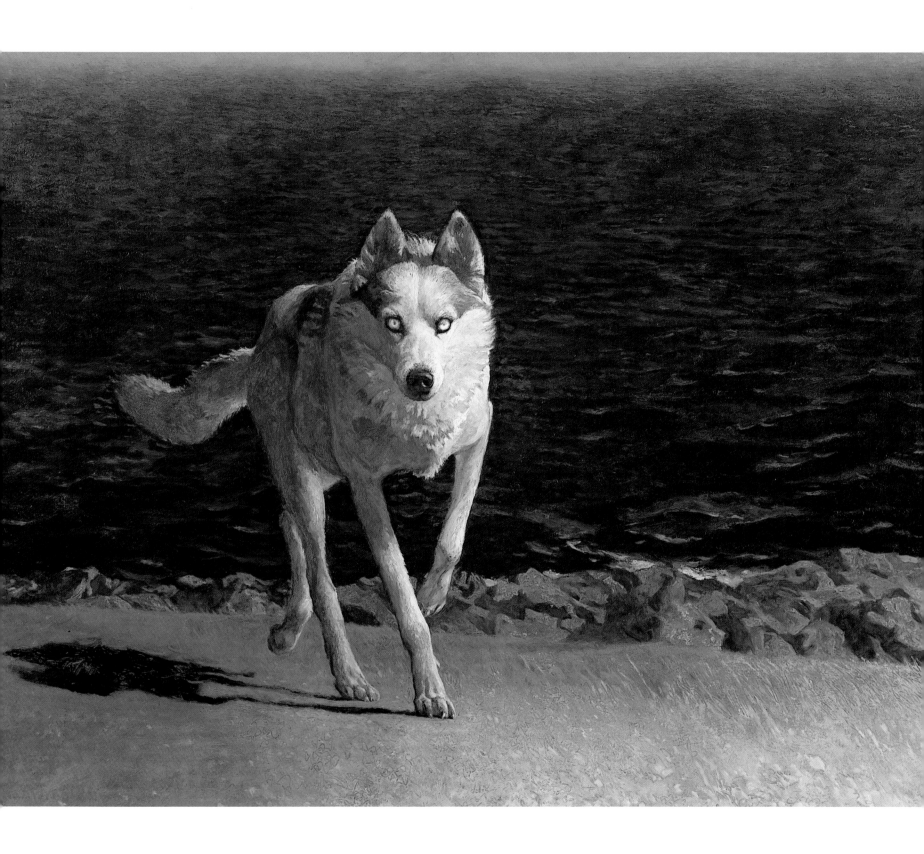

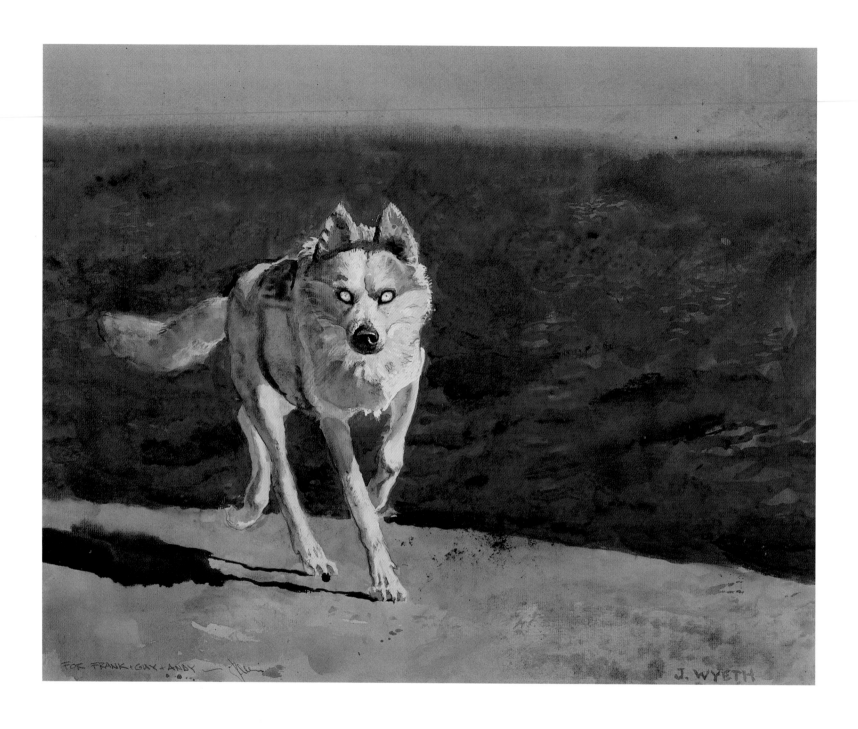

Study for Wolf Dog, 1976

Combined mediums on paper, 16 x 20 inches
Collection of Mr. and Mrs. Frank E. Fowler

His name was George, believe it or not. The first week I had him on the island he howled all night. A wolf has that howl. The islanders came to me after three days of this, and I had to do something. It was keeping them up. So then I brought him into the house. He had these pure white eyes which were really kind of scary. He was very at ease with me, but if I made any fast movement he'd be up and ready to go, very afraid. At night he ended up in my room. I would wake up and feel someone staring at me, and he would be standing next to my bed, staring. After I finished the painting I sent him back to Alaska. I didn't keep him because he would instantly kill anything smaller than himself.

I knew if I brought him to the farm he would wipe out all of the chickens and the dogs and so forth.

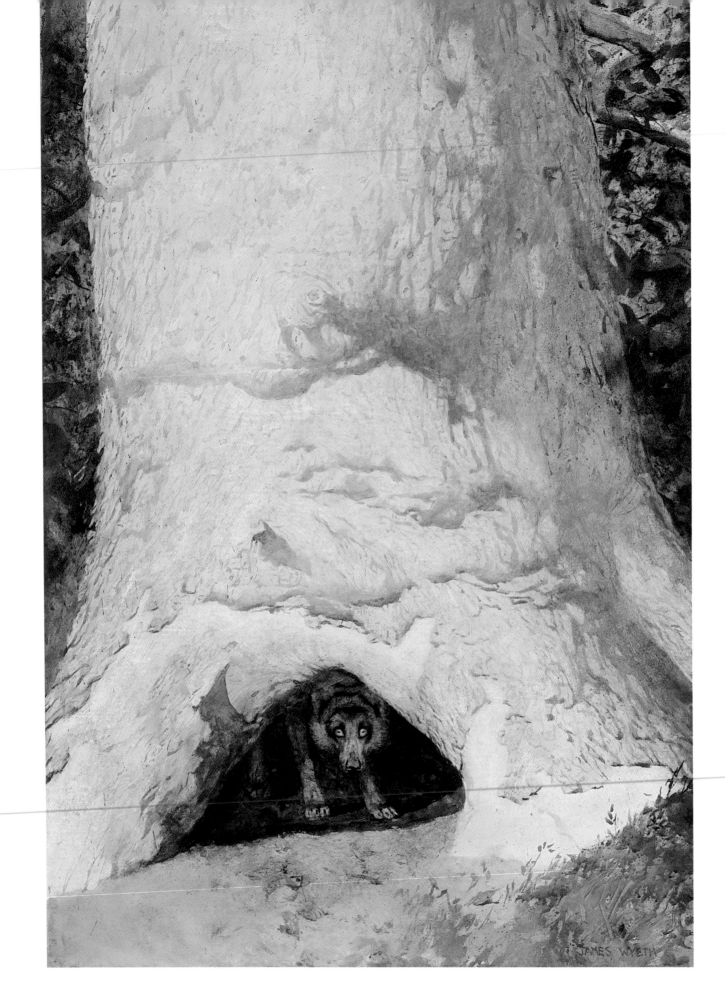

Tree Dog, 1976

Watercolor on paper, 37 x 25 1/2 inches
Private Collection
(Not included in the exhibition)

When I would take him to the interior of the island, he had a harness to wear and he would pull me up the hill. As I said, he was a sled dog. He'd go along and all of sudden he would go "boom," pounce and pull up a mole or field mouse. Anyway, on one particular day we were going along through the village and a cat was in the bushes. This cat was hissing, and I saw George's white eyes look into the bushes. I wondered what he'd do with this cat if I let him loose. So I reached out and unhitched him, and he was "boom" into the bushes, and then there was a "crunch." That was it for the cat. So I thought, "Oh shit, this is the island cat." So I threw my coat over it, and George and I went out to the cliffs on the headlands and gave him a burial at sea. For two weeks after, people were calling, "Fluffy, Fluffy."

Everybody in the village was hunting for this cat. George and I remained completely silent. He was going to diminish the population of cats, that's for sure, if he remained.

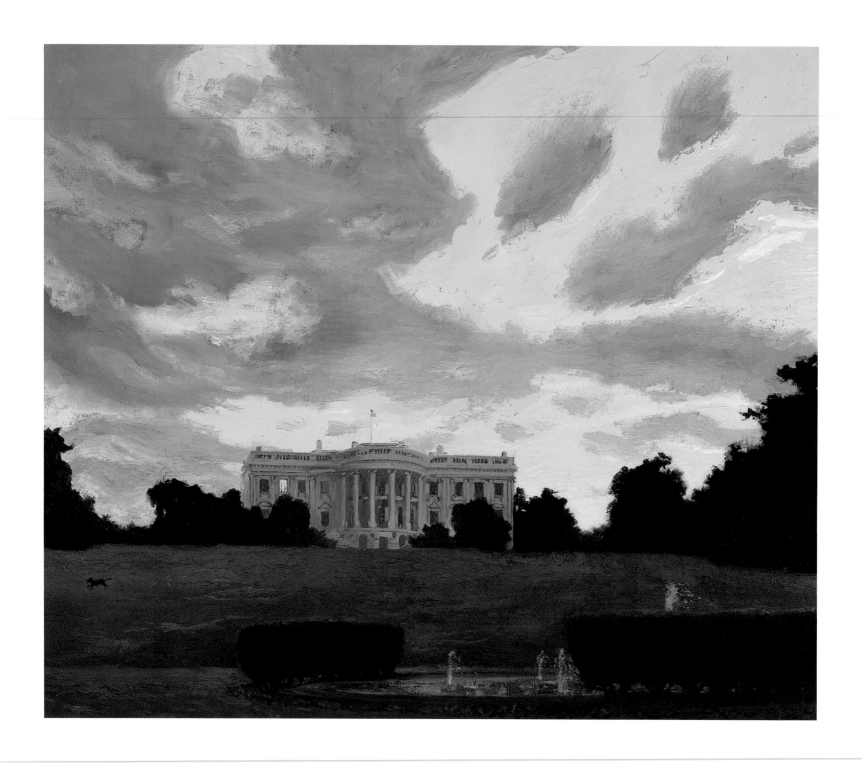

One day in the winter of 2000, I got up at 5 a.m. to paint on the south lawn of the White House.

Dawn, the White House, 2000

Oil on canvas, 30 x 36 inches
Private Collection
(Not included in the exhibition)

The arrangements were made with Hugh Sidey who was President of the White House Historical Association. When I got there, the guards said that my name was not on their list, but after a half an hour the White House kitchen engineer came to escort me to the south lawn around 6:30. Suddenly, I was surrounded by three black suited swat team-like figures ordering me to "freeze." I told them that I was there to paint the White House, but they looked at me like I was Lee Harvey Oswald. Finally, they got word that I was not a terrorist and reluctantly let me sit under a tree where I spread my jacket and rags on frosty ground and began to paint. They brought me a new badge to wear. The first one said, "White House Guest" because they thought I was an overnight guest of the Clinton's, and the new one read "Worker: Grounds Only." I tried to continue painting as the sun rose, hitting the top of the White House, when out of the bushes bounded the President's dog, Buddy. He jumped all over me and my paints and wanted me to throw a ball he was carrying – which I did.

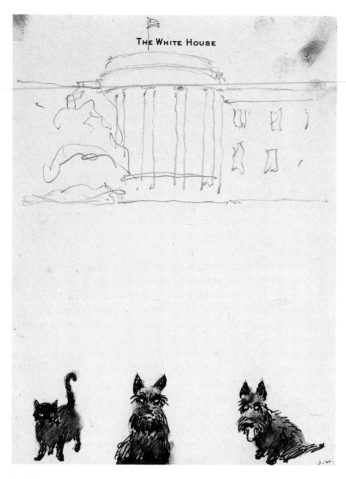

**India, Barney, and Miss Beazley Bush
Staring at Me (Study #1)**, 2005

Pencil and ink on paper, 7 3/4 x 5 3/4 inches
Collection of the artist

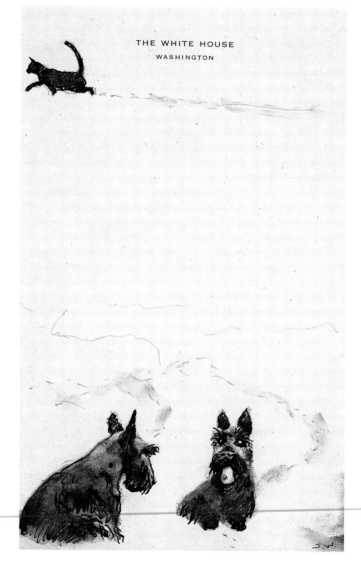

**Barney and Miss Beazley Conferring,
India Off (Study #2)**, 2005

Pencil and ink on paper, 8 x 5 inches
Collection of the artist

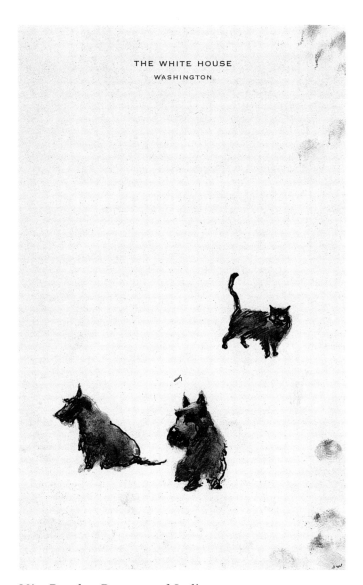

**Miss Beazley, Barney, and India
Bush (Study #5)**, 2005

Pencil and ink on paper, 8 x 5 inches
Collection of the artist

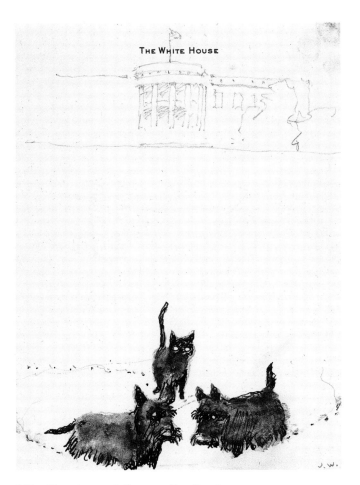

**Miss Beazley and Barney Conferring,
India Taking Notes (Study #3)**, 2005

Pencil and ink on paper, 7 3/4 x 5 3/4 inches
Collection of the artist

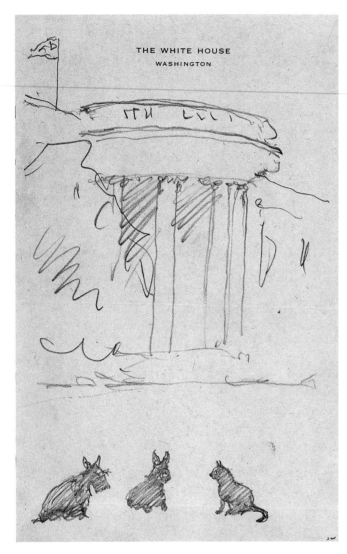

**Barney, Miss Beazley, and India Conferencing
in Front of the White House (Study #7)**, 2005

Pencil and ink on paper, 7 3/4 x 5 3/4 inches
Collection of the artist

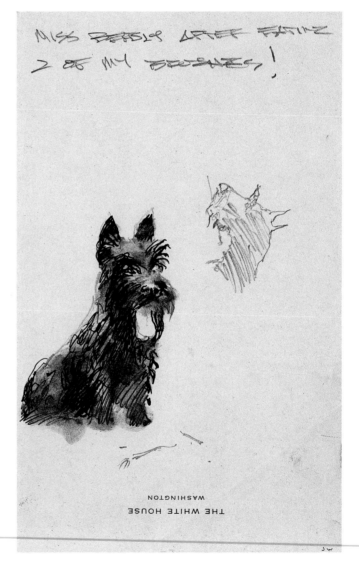

**Miss Beazley After Eating Two of
My Brushes (Study #8)**, 2005

Pencil and ink on paper, 8 x 5 inches
Collection of the artist

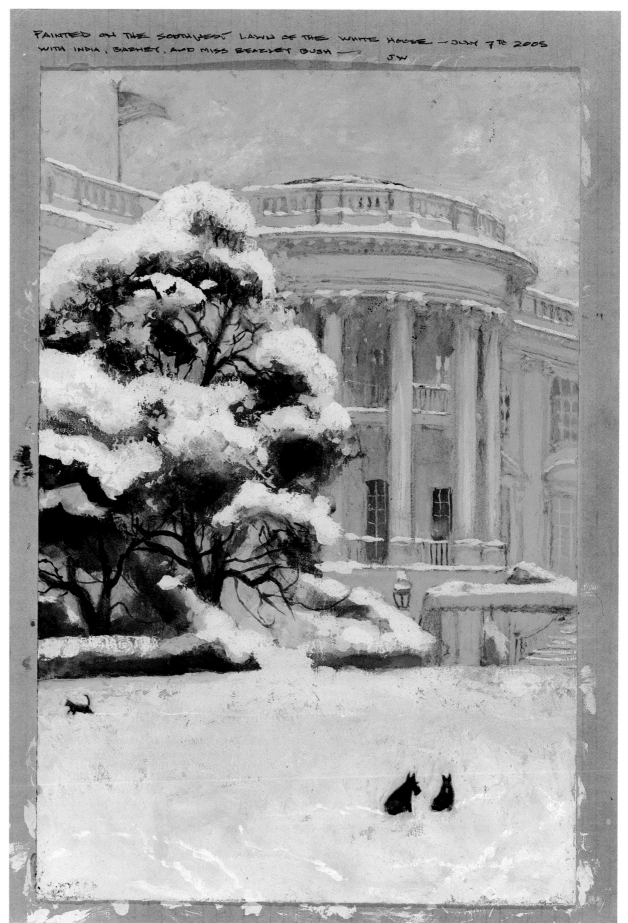

PAINTED ON THE SOUTHWEST LAWN OF THE WHITE HOUSE — JULY 7th 2005
WITH INDIA, BARNEY, AND MISS BEAZLEY BUSH —
JW

The Jackson Magnolia with Barney, Miss Beazley, and India Bush, 2005

Combined mediums on toned board, 16 x 10 1/8 inches
Collection of Mr. and Mrs. Frank E. Fowler

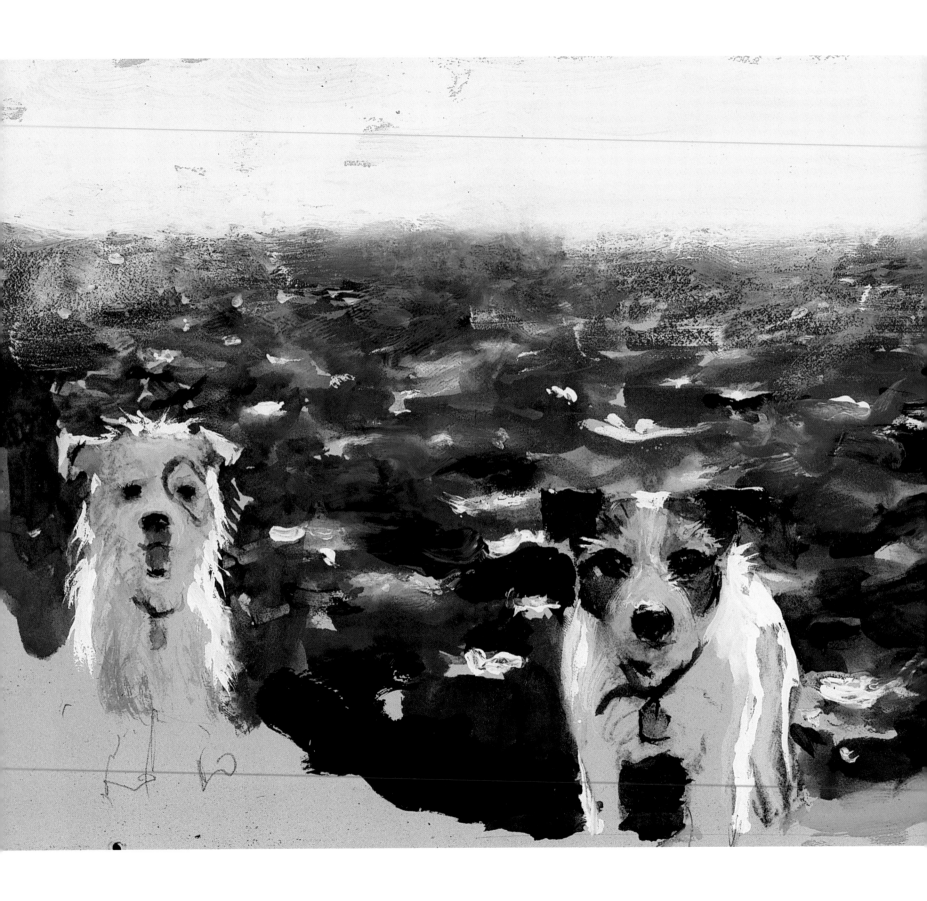

The dogs I have depicted are not necessarily my pets, but most of them are.

Because — like with people — when I do a portrait I need to know them personally.

Nothing interests me less than the cute looking dog or amusing looking dog. How I choose any subject is always sort of a mystery to me. I mean I'll know a person for 25 years, and some morning I'll jump out of bed and say, "Oh my God, I've got to paint him." I get so wildly excited, and here I've known them for years and years. So when I choose to paint a dog, usually it's a dog that I've known and lived with, and all of a sudden it strikes me that I have to record it. It's not necessarily something they do, it's just what I feel.

Ocean Dogs – Homer, Voler, Ziggy, 1999

Combined mediums on toned board, 9 x 13 1/2 inches
Collection of Phyllis and Jamie Wyeth

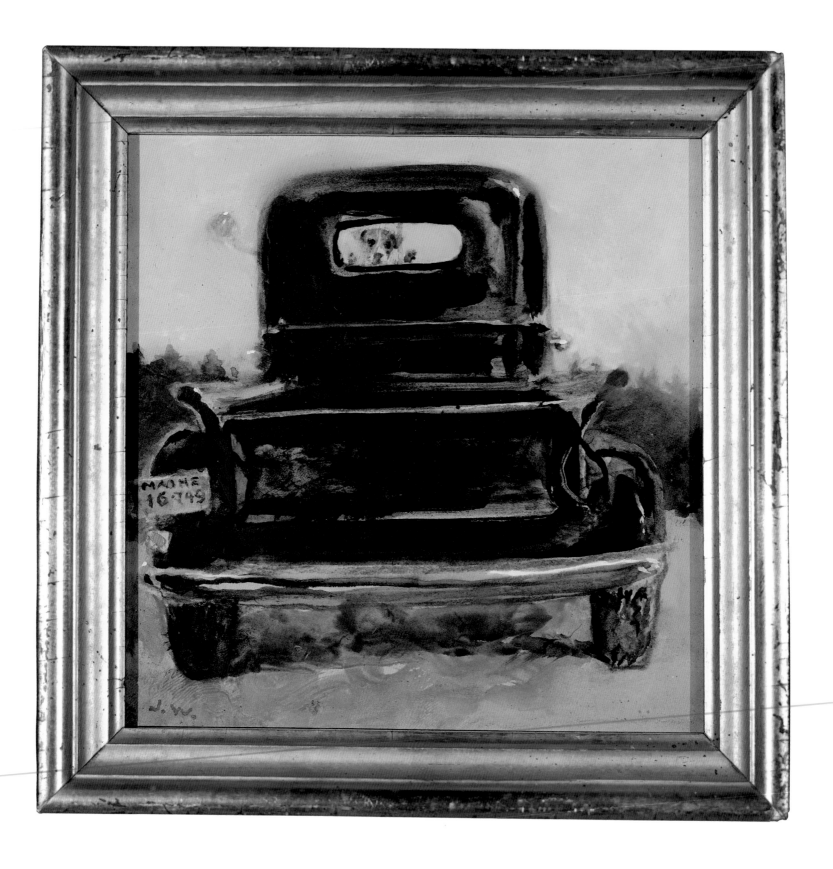

I mean painting to me is all about recording.
It's sort of my journal.

Tiller in the Pickup, 2002

Combined mediums on toned board, 9 3/4 x 9 1/2 inches
Collection of Phyllis and Jamie Wyeth

God knows why all of a sudden I have to record.
It's a great mystery to me.

Tiller Catting, 2003

Combined mediums on toned board,
10 1/4 x 7 1/4 inches
Collection of Phyllis and Jamie Wyeth

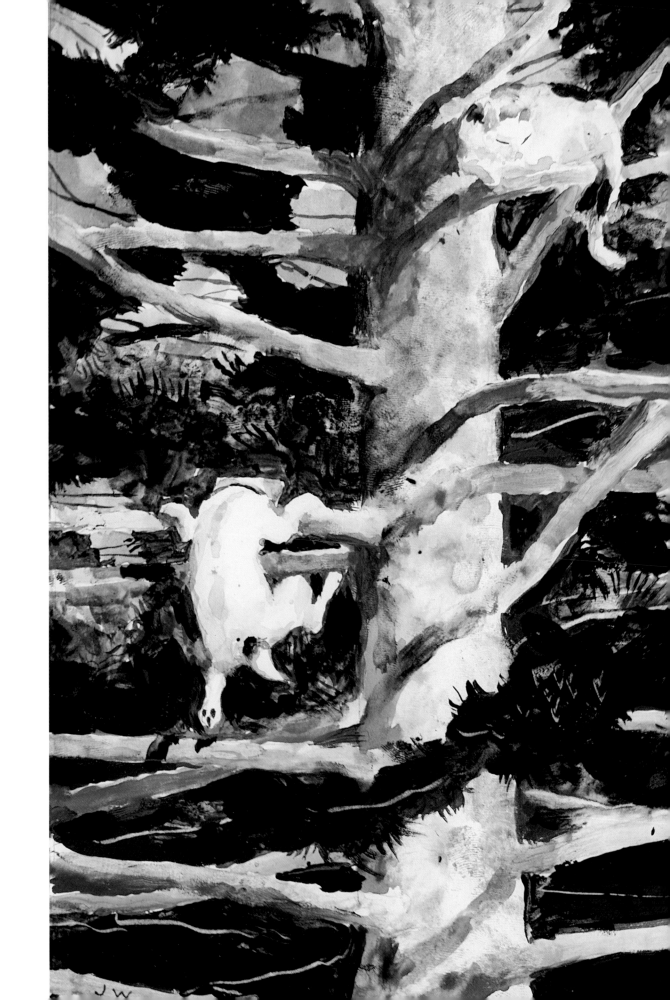

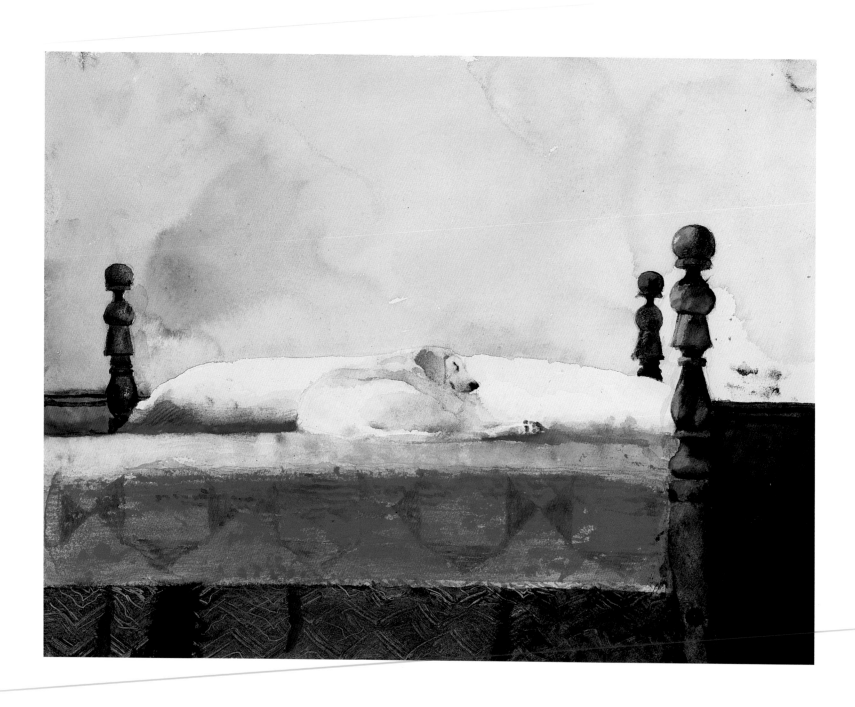

I have not looked at the history of dog painting. It's not like I'm going to be a dog painter or specialize in dogs.

I'm always interested in seeing how others work, though. There's a wonderful Italian painting with a dog asleep which is just stunning. I have a couple Munnings [Sir Alfred Munnings, British Painter, 1878-1959] with dogs and some other paintings of dogs. I love my father's [Andrew Wyeth's] paintings of dogs. They're terrific. So the influence is there in the sense that I've been fascinated by them. My grandfather's [N.C. Wyeth's] dogs were more props for hunters going back and forth. I can't think of any great N.C. Wyeth paintings with a dog.

Master Bedroom I, 1964

Watercolor on paper, 12 x 15 7/8 inches
Collection of the artist

I don't find one breed easier to depict than another. They are all difficult.

It is hard to get the real feeling of them and not make them cute. Yes, they can be cute and funny and so forth, but they can have a mean side. You think you are very close to a dog and you try to take a bone away from it. It growls at you. That is what is interesting about them. They are not pretty, cute and fun.

Skittish Dog, 2000

Oil on canvas, 36 x 26 inches
Collection of the artist

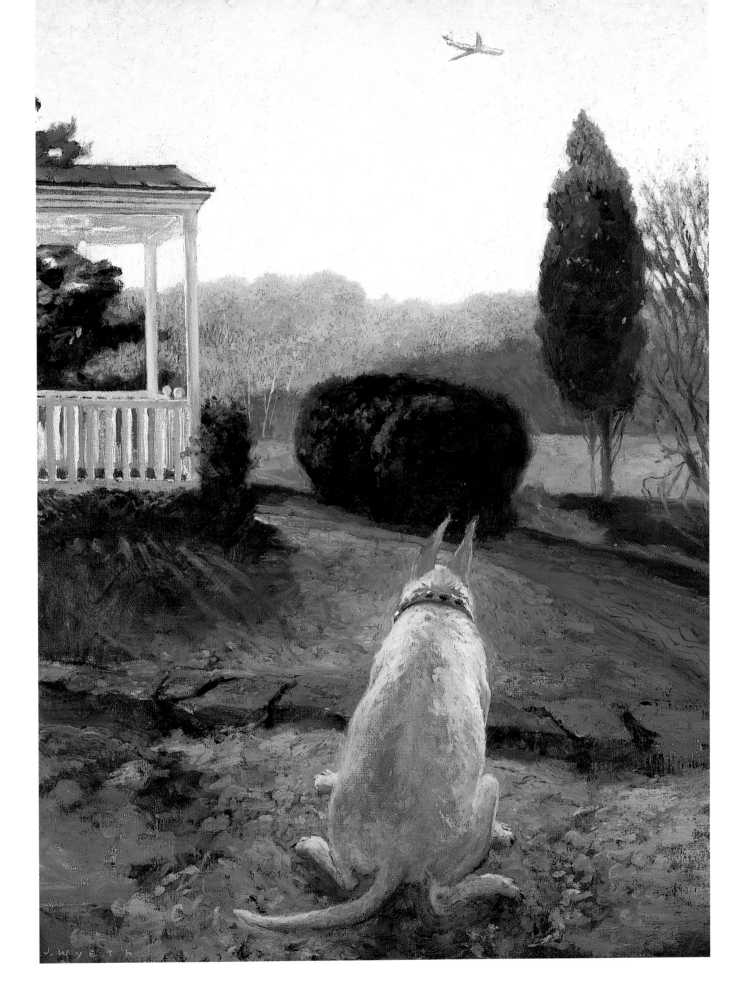

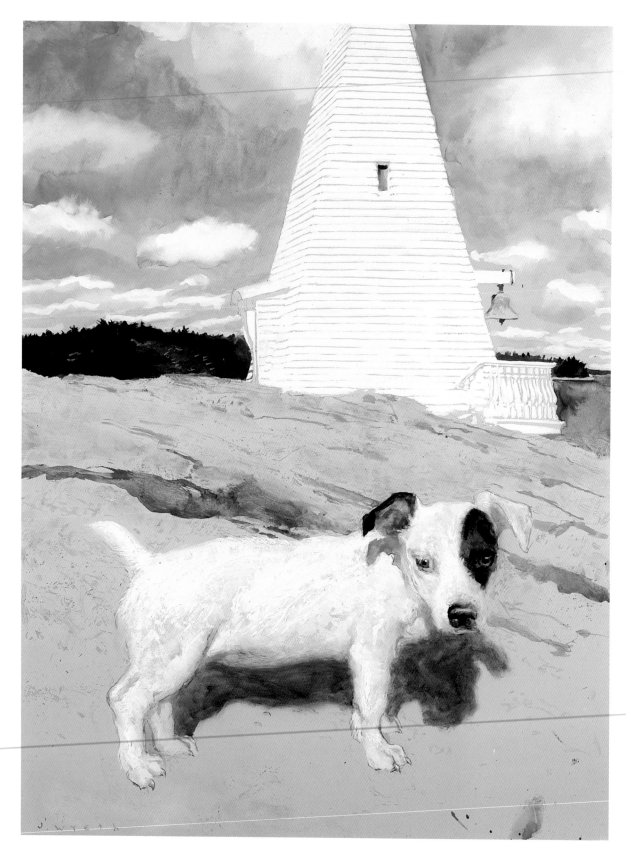

Iggy Pop and the Bell
Tower, 1995

Combined mediums on
toned board,
24 x 18 inches
Collection of Jamie Michaelis

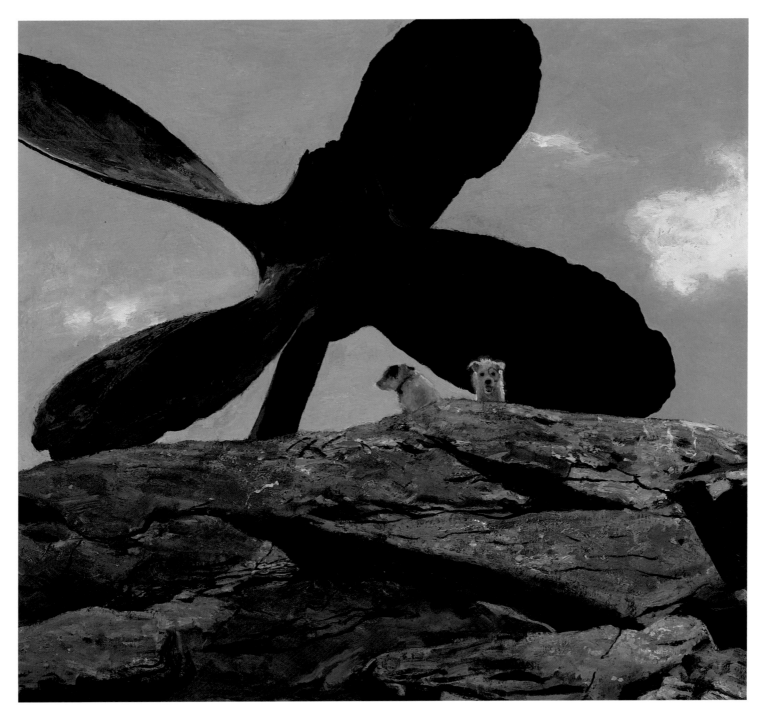

Wreck of the Polias, 2002

Oil on toned board, 27 3/4 x 31 inches
Collection of Mr. and Mrs. Frank E. Fowler

I am revealing some terrible secrets.
I don't have a favorite breed.

I just happen to have a lot of Jack Russells. I always hated small dogs and then somebody gave me a Jack Russell – my first. They are well described as big dogs with short legs. They do not have small dog mentality, and so I have them around a lot. So they are models.

Yolk and the Stump, 1987

Combined mediums on paper,
22 3/4 x 30 3/4 inches
Private Collection

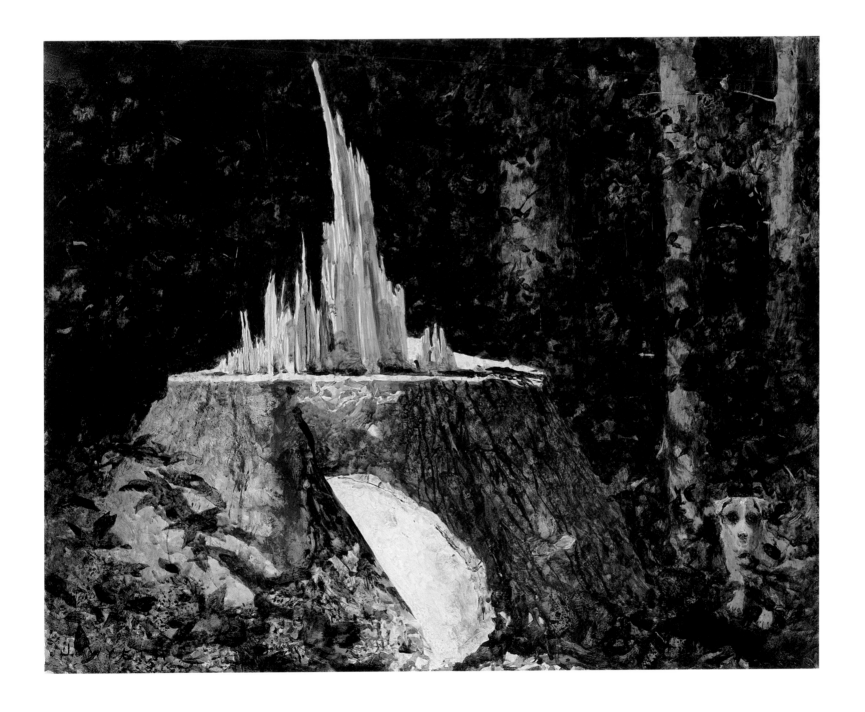

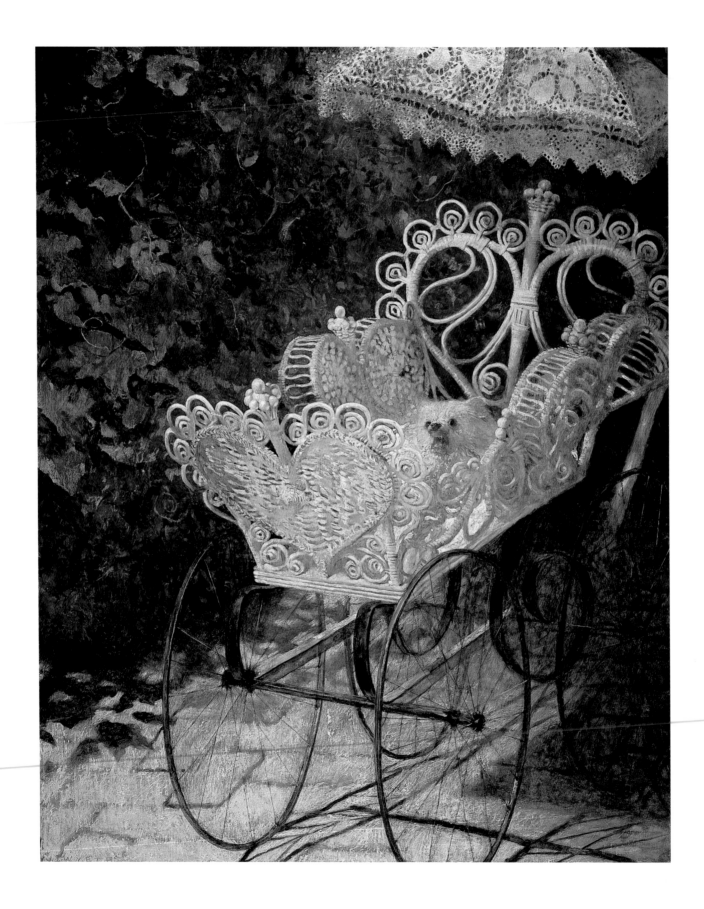

When I painted *A Very Small Dog,* I said that I hated small dogs, and the painting seems to convey that message.

That small dog in the work was a complete figment of my imagination. There was no such dog. Everything I hate about small dogs went into that painting.

I don't know how I got into that. Curiously enough the background is up at my grandfather's studio. It is in my grandmother's little garden outside of her window there. It's a combination of things, God knows how I stuck it all together. It's very odd! I think my intention was that your eye not go immediately to the dog, that you say, "Oh look, a little baby carriage — how pretty. There must be a child in there." And then all of a sudden this awful thing comes flying out with sharp teeth.

A Very Small Dog, 1980

Oil on canvas, 50 x 40 inches
Collection of the Brandywine River Museum
Gift of MBNA America, 2003

What people refer to as humor in these works is completely unrehearsed.

I don't plan these things, like Dozer who, whenever we walked through a certain part of the woods, would disappear into a tree. Clearly something lived in the tree. I couldn't hear a bark, but you'd see his little anus pop up every time. And he'd dig and cover beautiful wildflowers with dirt. It was a serious operation for Dozer. He did not do that to be amusing.

Jack Russell Attacking a Tree, 1985

Combined mediums on paper,
36 x 29 1/2 inches
Private Collection

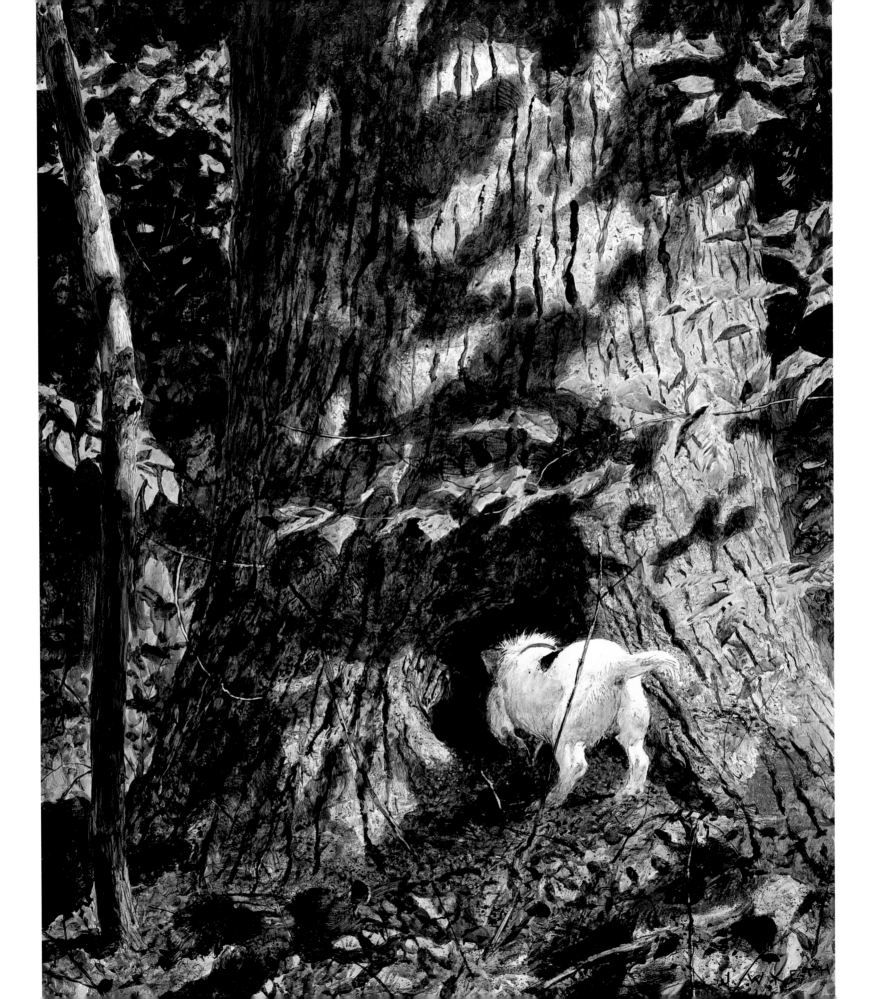

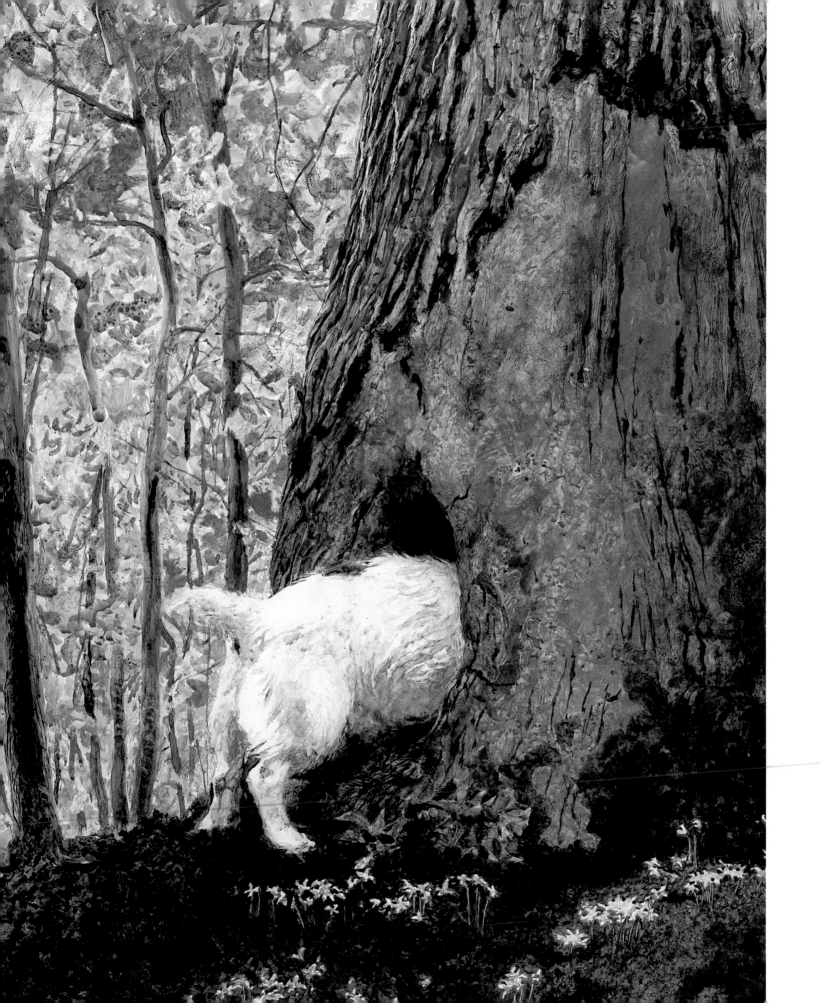

Robert Rosenblum [the art historian] obviously had a love for dogs and sort of an obsession. And after we did some work together, he wrote to me about my dogs and his dogs. That's when I sent him the study for *Squirreling*. With the Jack Russell breed all you see is rear ends because they are usually going after something.

I love the humor in dogs because it's completely unrehearsed, it's not like they're doing a comedy review.

Squirreling, 1989

Combined mediums on paper,
28 1/2 x 22 1/2 inches
Collection of the artist

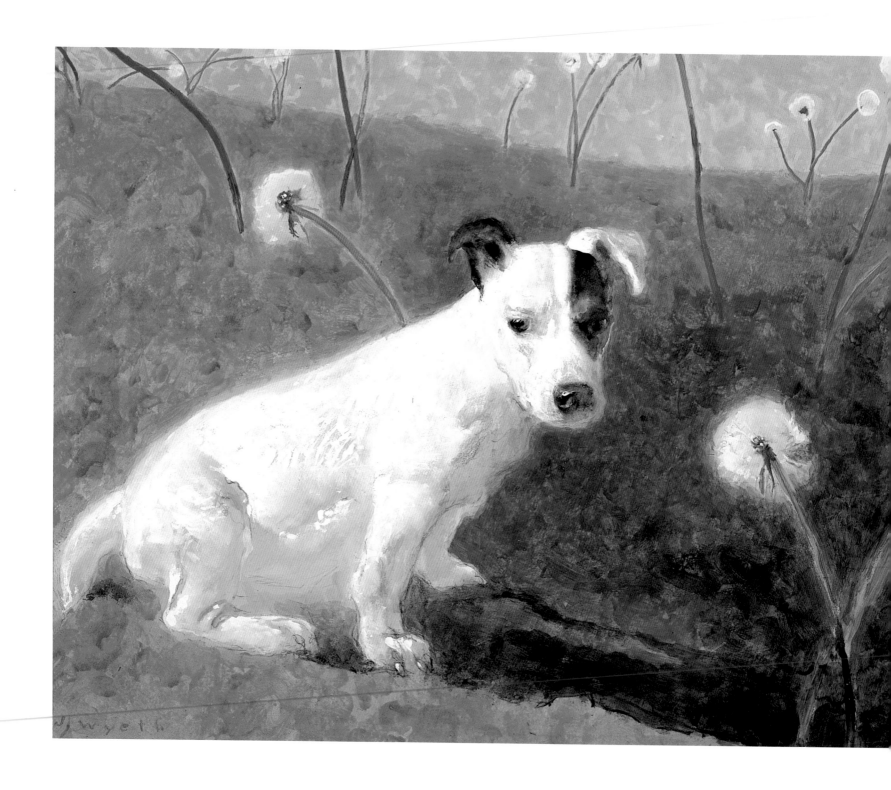

There was a wonderful article recently saying that they are a species in constant pursuit of the absurd, which is a perfect description of them.

Jack Russells are easy to transport, and on my island they go back and forth and adapt pretty fast. So, I've come to sort of like small dogs. I mean that particular breed of small dog. I'm not crazy about Chihuahuas, but maybe I could fall in love with one, who knows. It's that piercing bark that always puts you off. Oh my God!

Iggy Pop and the Dandelions, 1997

Combined mediums on toned board,
18 x 24 inches
Collection of Daniel K. Thorne

We have four Jack Russells. That's fine for now. As I say, these Jack Russells are really like big dogs.

Ziggy on Ice, 1998

Combined mediums on toned board,
30 x 22 inches
Private Collection

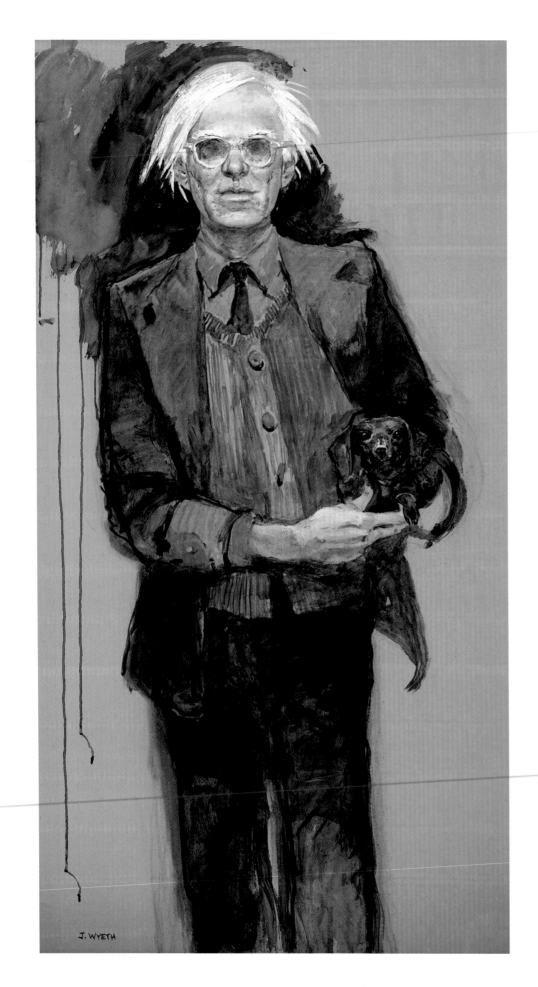

J. WYETH

I don't find any particular medium better for any particular animal or part of an animal.

I am a very odd technician in that I use my fingers mostly and sticks and pieces of cloth. Really, I use brushes less and less. I always felt that you shouldn't be limited by your medium, and I think when people say "watercolor" they see in their mind's eye some washes and color. I now work watercolor like oil. I use it straight out of the tube, very thick, and patched on. That sort of thrills me – I love the idea that you can push the medium and treat it as oil. So combining mediums is intriguing to me. In my studio, I have pastels lying on the floor, I have watercolor, oil, charcoal, and I like jumping back and forth.

Andy Warhol – With Archie – Front View – 3/4 Figure (Study #7), 1976

Combined mediums on cardboard, 53 x 30 inches
Collection of Sherry Kerstetter

There is no medium I necessarily prefer for animals,

but, generally, what I call "combined mediums" is faster, and with an animal you want to work pretty rapidly.

"Albert squeezed his eyes shut as the dog ran past" from *Cabbages and Kings*, 1996

Combined mediums on paper, 9 1/2 x 12 1/2 inches
Collection of the artist

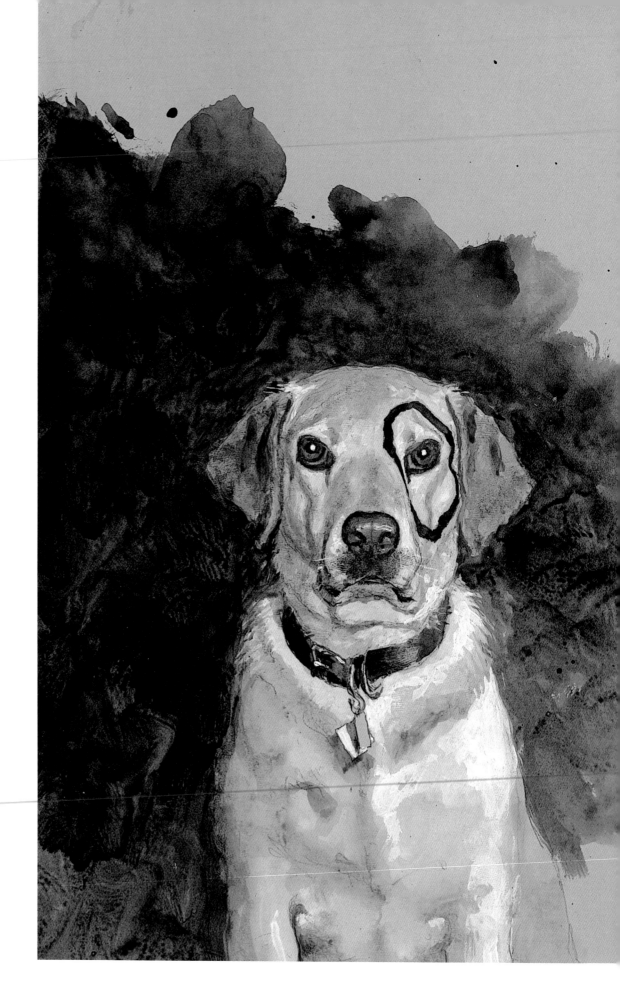

Kleberg Study with Eye and Inscription, 1984

Combined mediums on toned board, 20 1/2 x 21 1/2
Collection of Brock and Yvonne Vinton

I don't prefer to begin with the same medium always. Oddly, sometimes it seems reversed; I will do an oil, and then I'll go back and do drawings.

I don't know why I do it, but sometimes when you spend a tremendous amount of time on something there's a relief in saying, "Well, it's finished. I reached a point of diminishing returns." And then you look at it and think it could be interesting in some other medium, or, because I spent so much time, let me try it in a more rapid way.

Study for Voles, 1996

Combined mediums on toned board,
20 x 16 inches
Collection of Mr. and Mrs. Richard Sanford

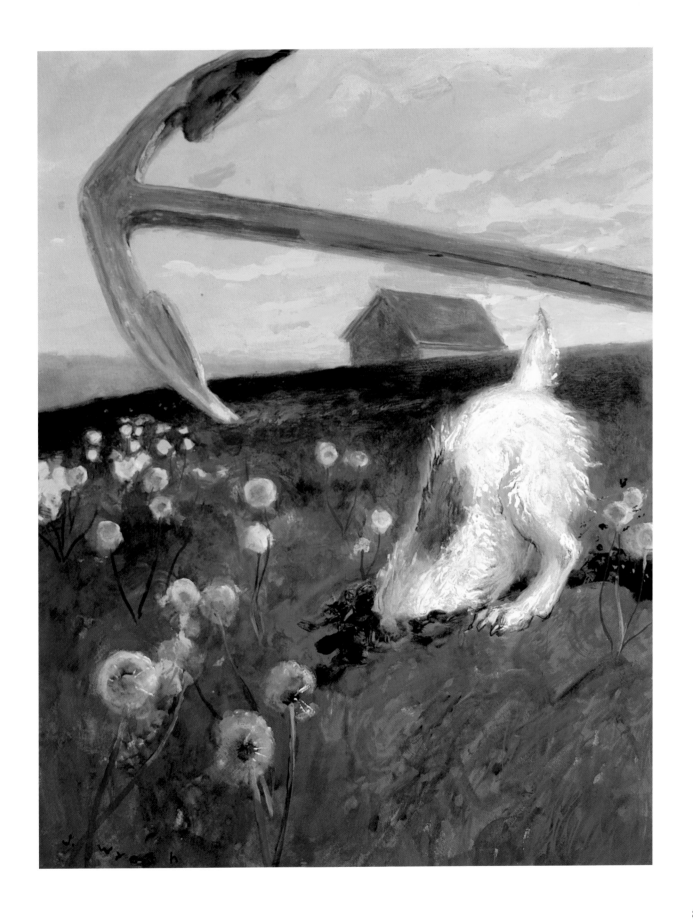

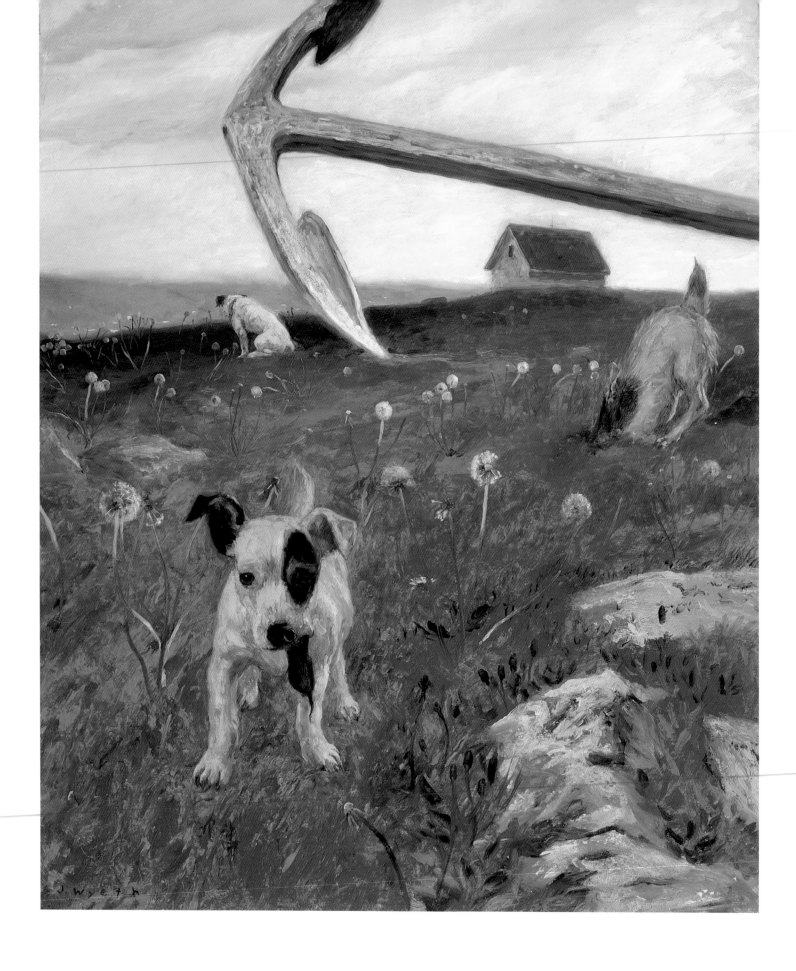

Of course, the very interesting thing to me is when it begins — whether it be a portrait of a dog or something else — it could begin with just a line on a page, which means nothing to another person, but to me means everything.

That line represents a thought. And then you get something that finally triggers a work, whether it be a study or something else, and you base the rest of the work on that one study. Well then, after spending weeks, you go back and look at it and wonder what in the hell interested you in that thing — because often the more you work on something the more other things will develop.

Voles, 1996

Oil on panel, 32 x 26 inches
Collection of Daniel K. Thorne

Homer, 2003

Combined mediums on toned board,
5 3/8 x 6 1/4 inches
Collection of Mary Beth Dolan

So clearly the thing that triggers a painting is usually obscure by the time it's completed.

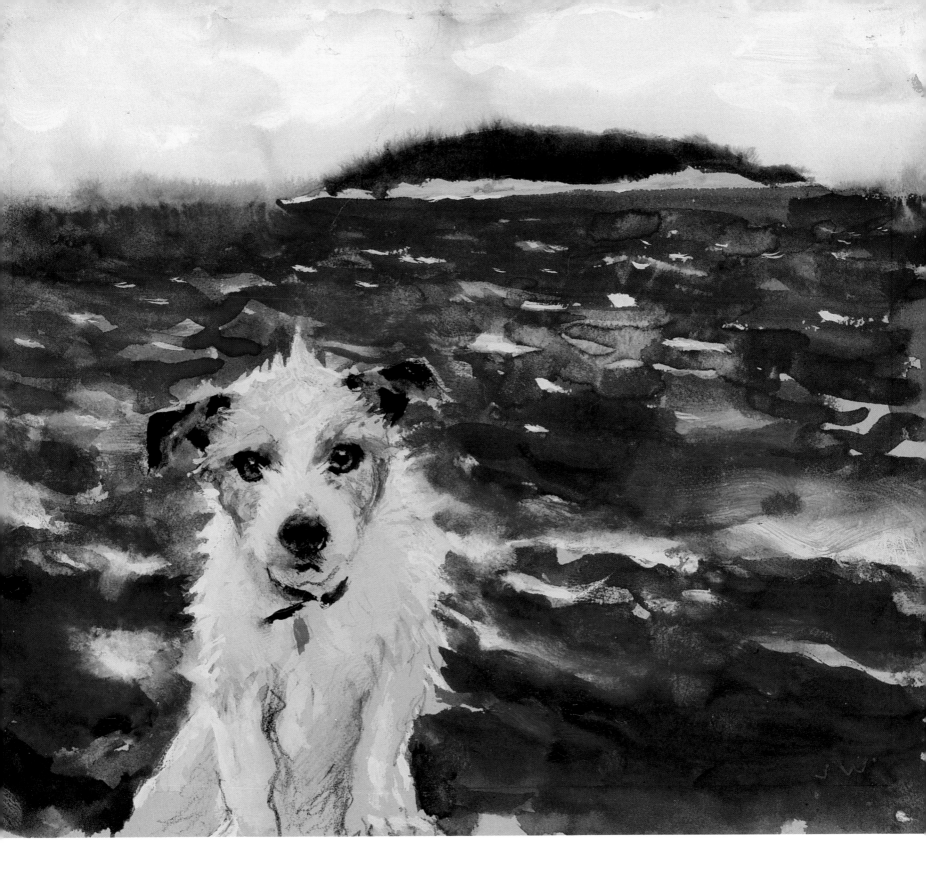

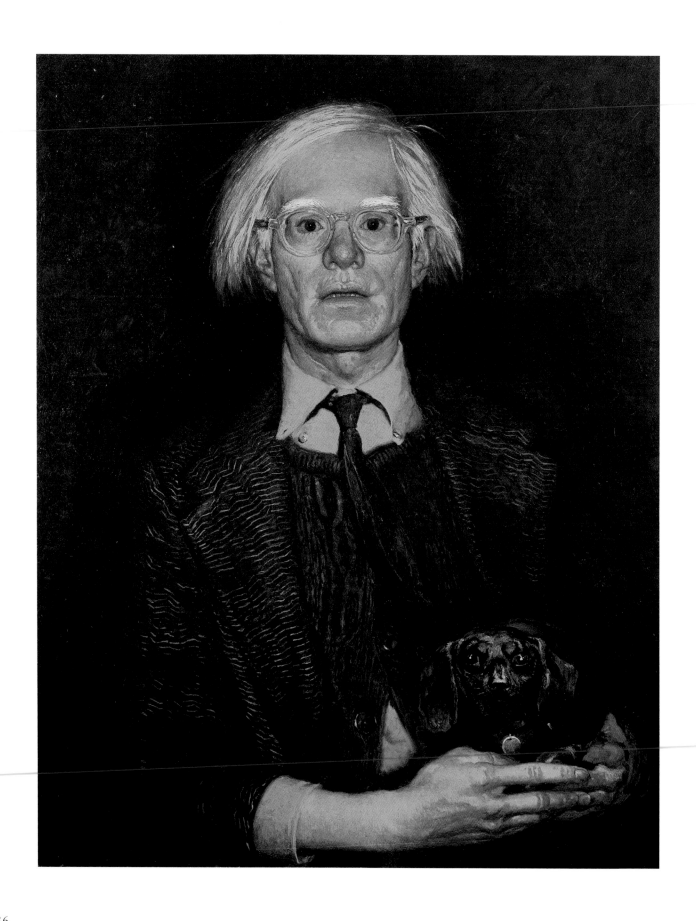

I bought as many stuffed dogs as I could. I've painted legs from taxidermy dogs, but I haven't done an actual portrait of a stuffed dog.

Portrait of Andy Warhol, 1976

Oil on panel, 30 x 24 inches
Collection of Cheekwood Botanical Gardens and
Museum of Art, Nashville, Tennessee
(Not included in the exhibition)

Andy Warhol and I found this place with a display in this beautiful glass case. It's a dog and cat. It's really quite wonderful. I was just fascinated that they stuffed dogs. I thought it was incredible that it was all done in the 20's and 30's. Andy ended up with Cecile B. DeMille's Great Dane. There on the dog was his name and the dates he was born and died. I would assume the Warhol Museum has that, but I don't know. Stuffed dogs or real dogs, there's no distinction. They're all the same to me. The convenience is you don't have to feed the stuffed ones. You put them away when you don't need them and just bring them out when you do. They don't keep you up at night. I have the best time with those things. When new people are coming to the house, I'll put either a dog or cat outside by the door and then, when I see lights come down the driveway, I'll go and listen. And you'll hear people come up the walk and say, "Oh look, Harry, there's a kitty. Come on. Oh, he must be sick, he looks so sad." They either step over him and come into the house or else they say, "Oh my God, I think he's dead." The stuffed animals I have are beyond count, I think. And the problem is that I've used them so much that some of them have seen better days. Ears start dropping off, and every Halloween, if someone new is staying in the house, I have to put one in the shower. It usually really gets the guests.

For me, dogs are often substitutes for their owners.

P.W. and Dozer, Christmas Morning, 1993

Combined mediums on toned board,
4 3/4 x 6 3/4 inches
Collection of Phyllis and Jamie Wyeth

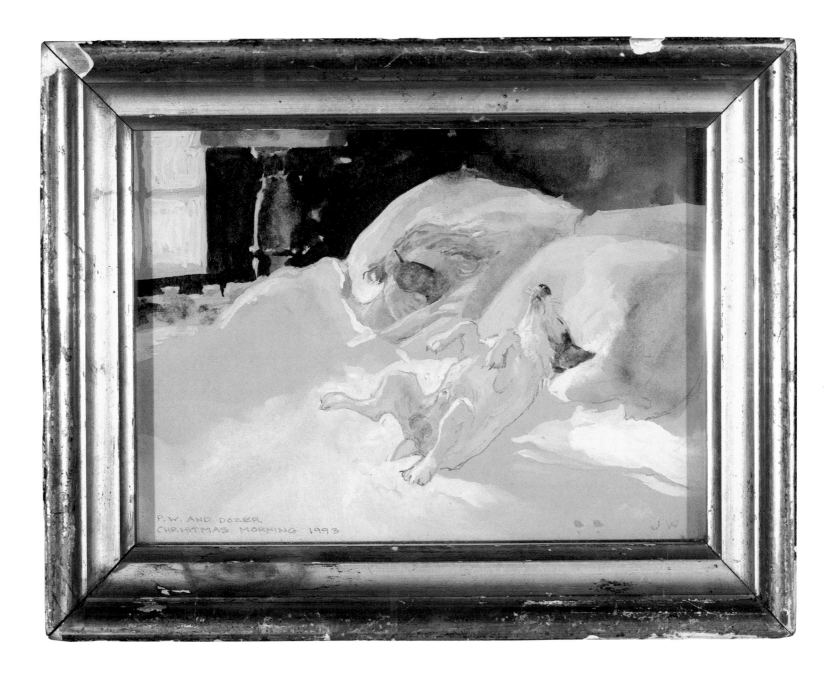

I think living with an animal causes some people to become the animal and vice a versa.

So some of the dogs I painted are definitely stand-ins for their owners. Dogs have their own sort of personality, but I think this whole thing about looking much like a person is silly. But of course they take on moods and can be very moody. As I have said before, I put as much study and concentration into the portrait of a dog as I do with a person. I don't do dog portraits per se, commissions. But maybe I should say $400,000 for a small one, a very small one.

P.W. and Ziggy, 1998

Combined mediums on toned board,
13 x 9 3/4 inches
Collection of Phyllis and Jamie Wyeth

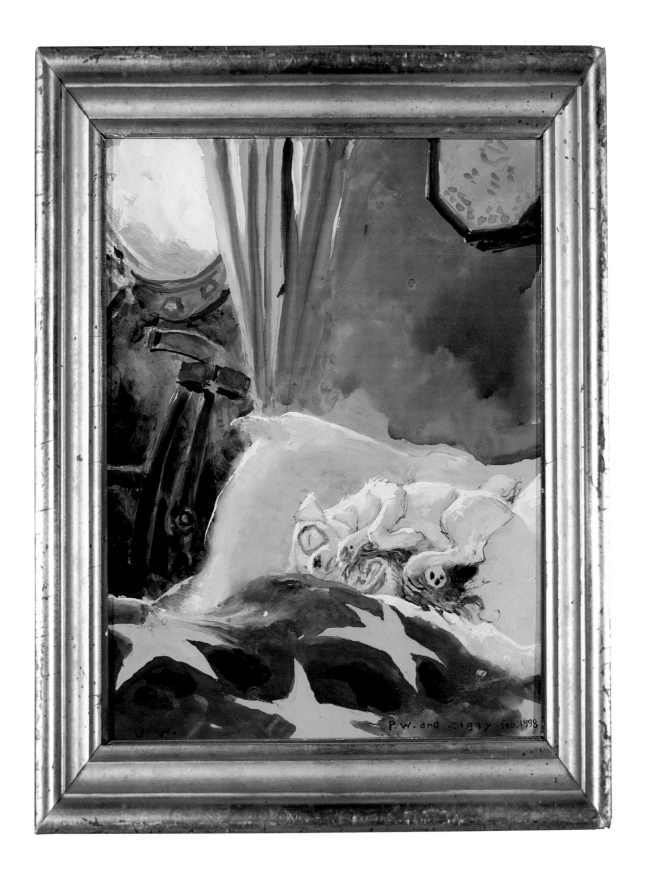

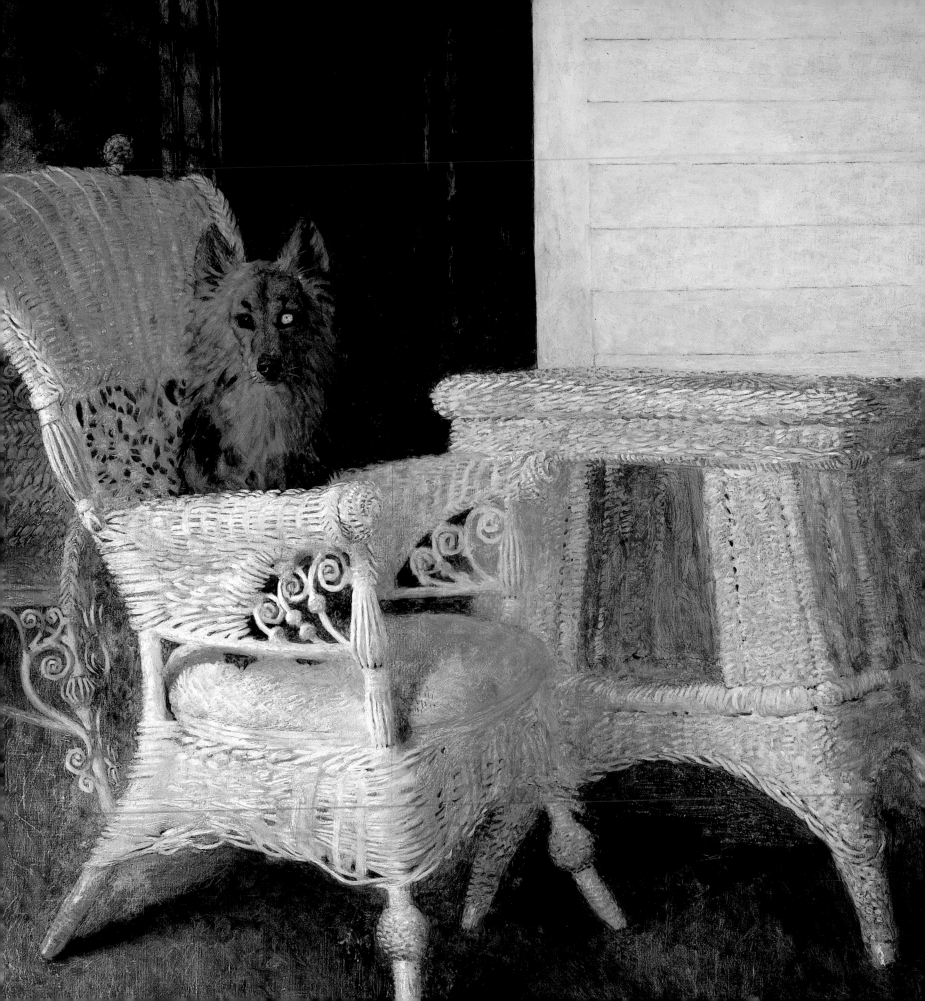

Animals fascinate me, but I draw no distinction between a portrait of a person and a portrait of a dog — or of a bale of hay for that matter.

I go about it with equal intensity and an equal amount of time, spending a lot of time, as I do with a human portrait. For sure, I've done portraits of certain houses. They are essentially portraits, not just scenes. But there is something about an animal, and in some of the dogs, like the Newfoundland where his head is larger than a human's head, it is something fantastic. You get eye contact with him so terrifically.

Angeload, 1979

Oil on canvas, 25 x 25 inches
Collection of Phyllis and Jamie Wyeth

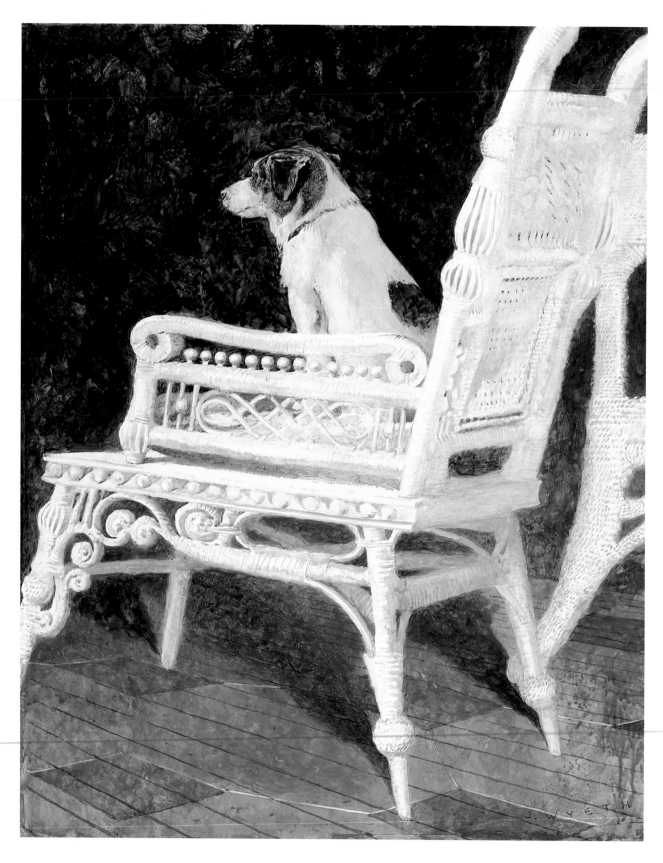

Yolk and the Wicker Chair, 1987

Combined mediums on paper, 29 x 23 inches
Private Collection

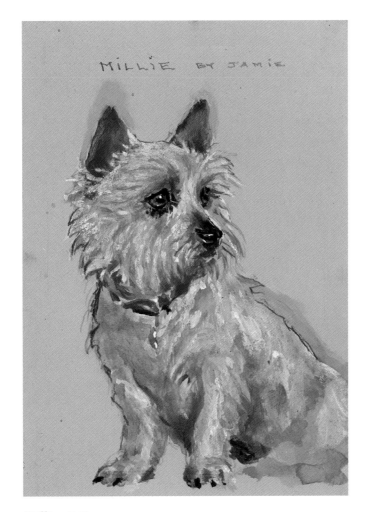

Millie, 1999

Combined mediums on toned board,
8 x 5 inches
Private Collection

I don't find being with people easy and being with animals isn't easy.

I think there is no animal that is more interesting than the others. The thing about dogs is that they have continued to interest me through my whole career. I definitely had a period when I was chicken crazy. Then I got into Purple Martins. I was completely obsessed with them. Then, it goes on – pigs at one point.

Kleberg and Dozer, 1987

Combined mediums on toned board,
16 x 20 inches
Collection of the artist

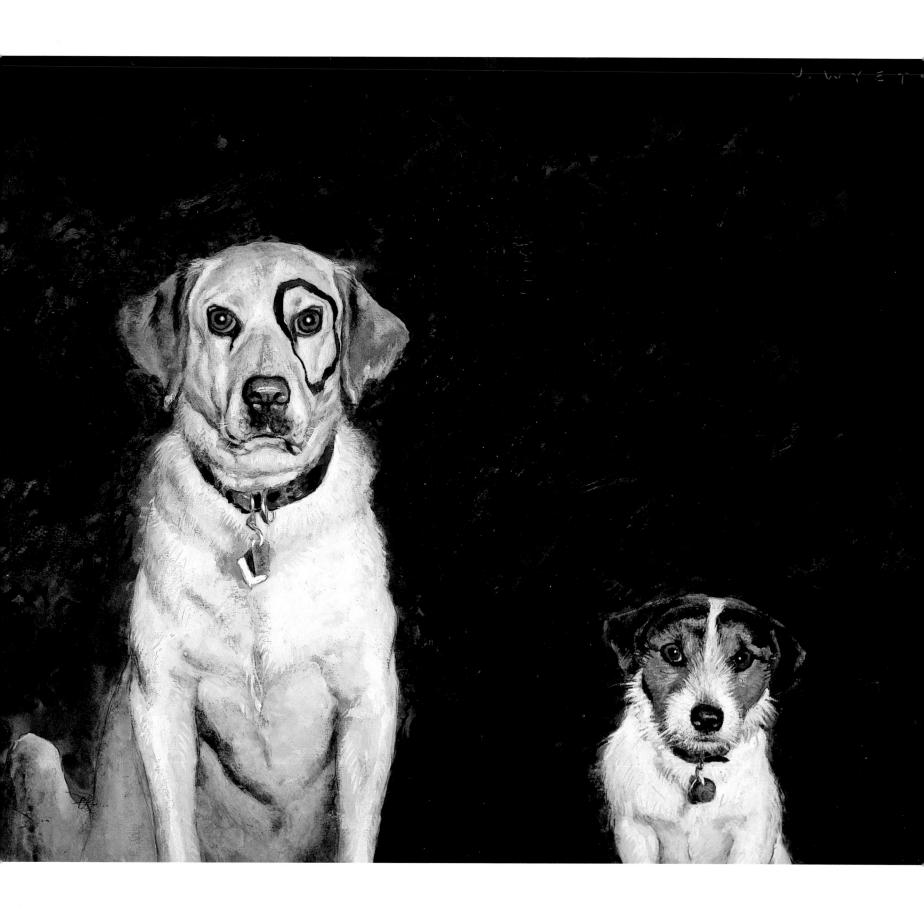

I much prefer dogs to people. When working with dogs your mind can wander.

I love to daydream and I can't daydream with people next to me.

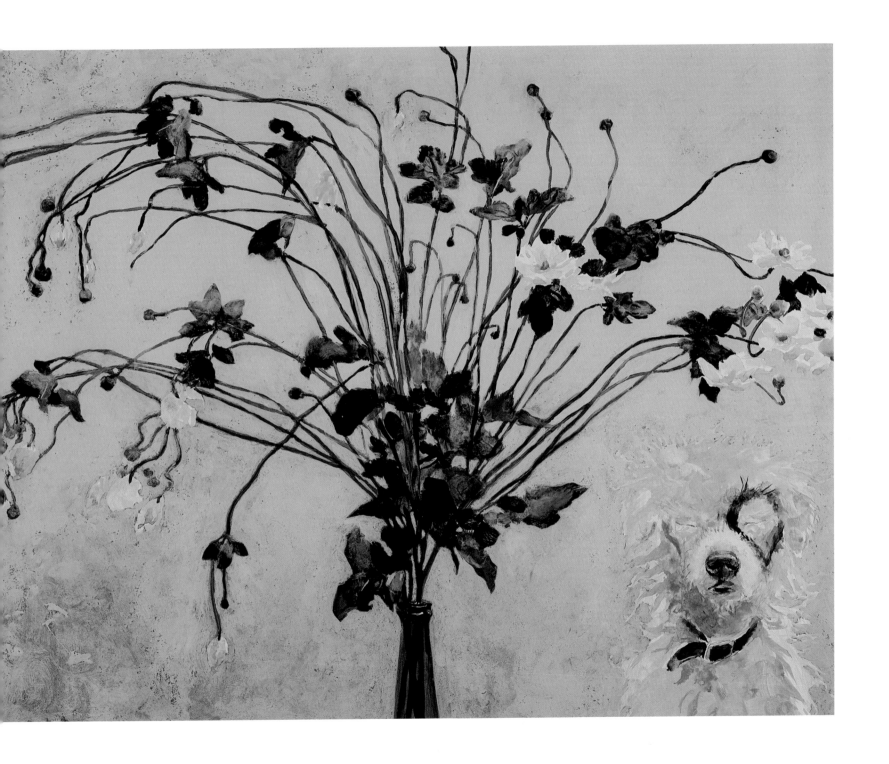

The Jeep, 2002

Combined mediums on toned board,
9 3/4 by 15 1/2 inches
Collection of the Cawley family

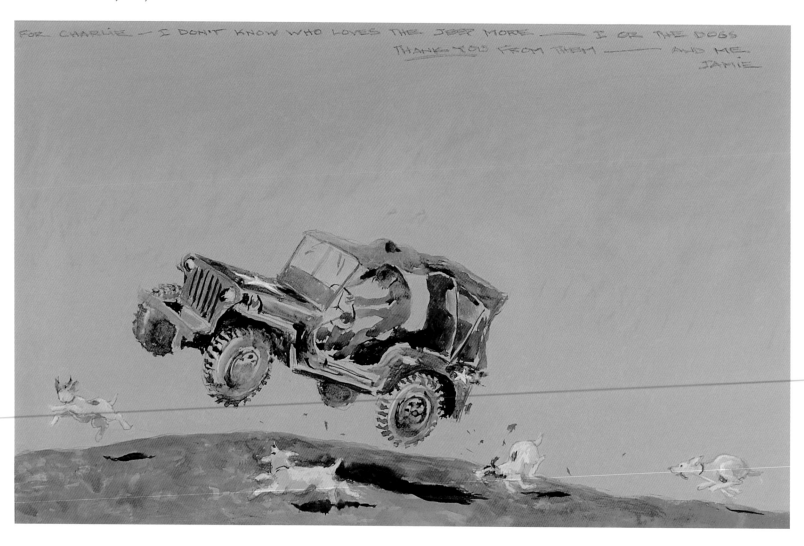

Year of the Syncope, 2000

Combined mediums on toned board,
6 x 4 inches
Collection of Phyllis and Jamie Wyeth

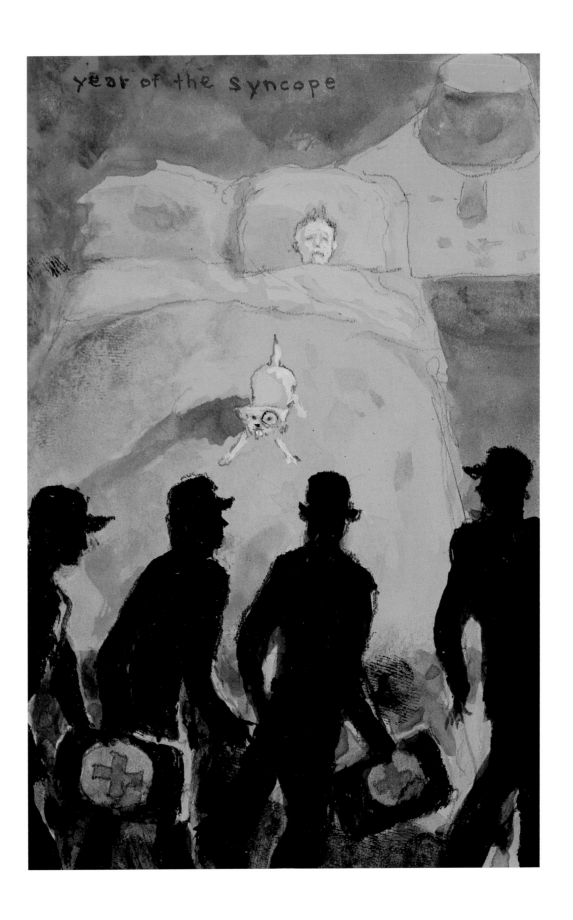

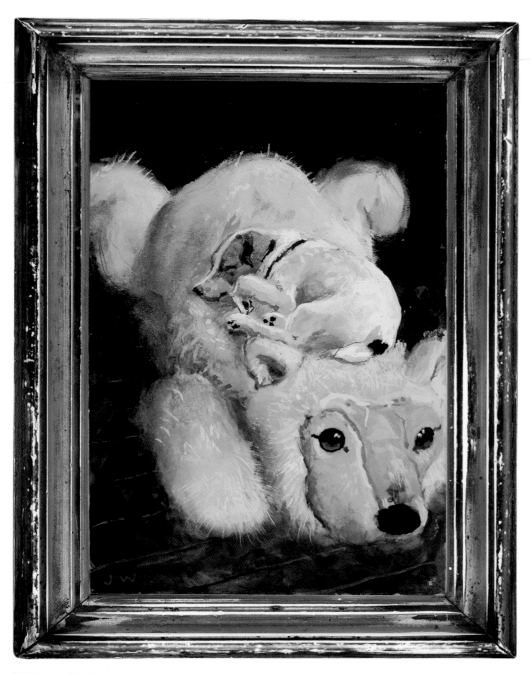

Tiller on his Bear, 2001

Combined mediums on toned board,
7 1/4 x 4 1/4 inches
Collection of Phyllis and Jamie Wyeth

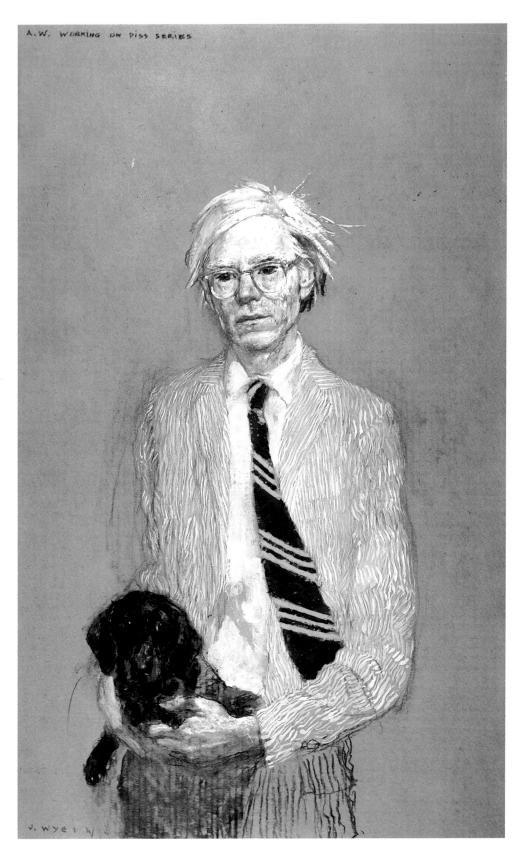

A.W. Working on Piss Series,
1977-2007

Combined mediums on cardboard,
48 x 30 inches
Collection of the artist

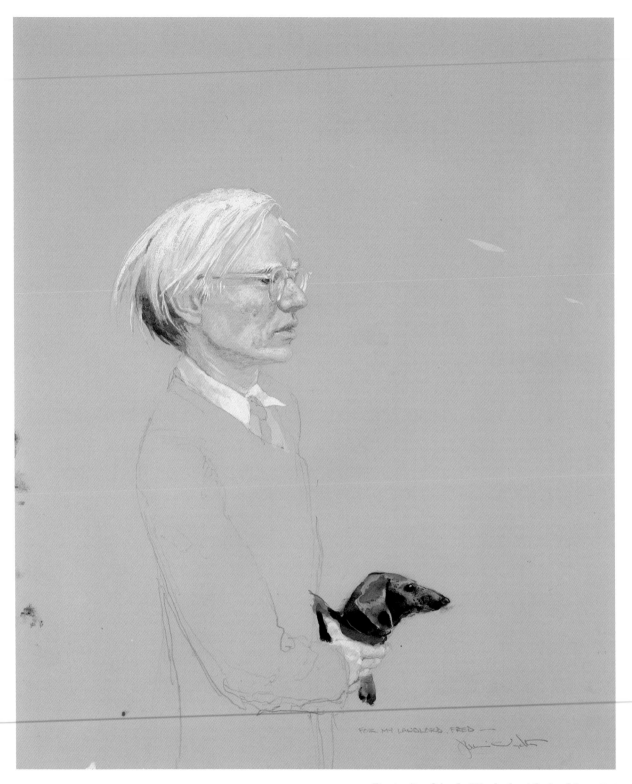

FOR MY LANDLORD, FRED

Portrait of Andy Warhol with Archie, 1976

Pencil and gouache on paper, 16 x 13 3/4 inches
Lent by Thomas Colville Fine Art, LLC

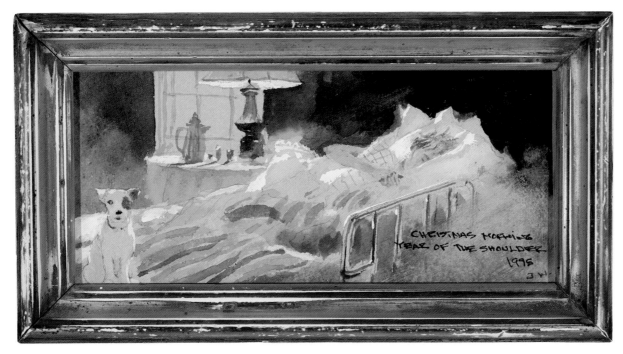

Christmas Morning, Year of the Shoulder, 1995

Combined mediums on paper, 3 1/4 x 8 3/4 inches Collection of Phyllis and Jamie Wyeth

Index

Page numbers in bold refer to works in the exhibition.

Barney (Study #4),
2005

Pencil and ink on paper,
5 x 8 inches
Collection of the artist

**Miss Beazley and
Barney Trailing India
Bush (Study #9)**, 2005

Pencil and ink on paper,
5 x 8 inches
Collection of the artist

Stealing Holly, 2004

Combined mediums on toned board,
5 3/4 x 7 1/8 inches
Collection of Phyllis and Jamie Wyeth

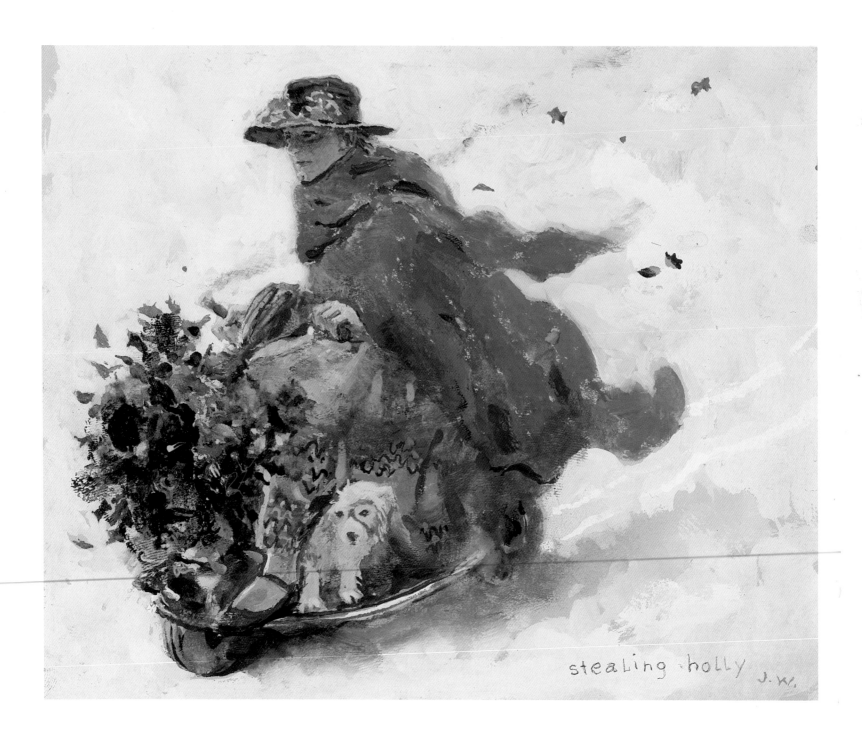

stealing holly J.W.